COLLAGE,

ASSEMBLAGE,

AND

ALTERED

ART

COLLAGE, ASSEMBLAGE, AND ALTERED ART

DIANE MAURER-MATHISON

WATSON-GUPTILL

PUBLICATIONS

NEW YORK

Executive Editor: Joy Aquilino

Editor: Martha Moran

Designer: John Gall and Chin-Yee Lai

Production Director: Alyn Evans

Cover design: John Gall

First published in the United States by

Watson-Guptill Publications

Nielsen Business Media,

a division of the Nielsen Company

770 Broadway

New York, New York 10003

www.watsonguptill.com

Library of Congress Cataloging-in-Publication Data

Maurer-Mathison, Diane V. (Diane Vogel), 1944-

 Collage, assemblage, and altered art : create unique images and objects /
by Diane Maurer-Mathison.

 p. cm.

 Includes index.

 ISBN 978-0-8230-7113-5 (pbk.)

1. Collage--Technique. 2. Assemblage (Art)--Technique. 3. Handicraft.

I. Title.

 N6494.C6M38 2007

 702.81'2--dc22

 2007027913

Printed in Thailand

Second printing, 2008

2 3 4 5 6 7 8 9 / 15 14 13 12 11 10 09 08

Cover: (Left) *Fourth of July* by Robert Villamagna
(Right) *The Metamorphasis of Minerva* by Opie O'Brien

Overleaf: *It's a Jungle*, a photomontage by Jeffery Mathison.

Opposite: Although the fine detail in *Suburban Garden*
by Anne Kenyon suggests that part of the image was
drawn, the collage is entirely composed of pieces of
Anne's handmade paper.

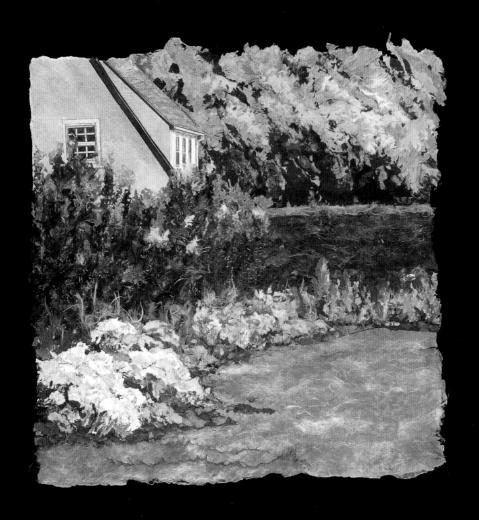

ACKNOWLEDGMENTS

*Thanks to all the amazing artists who shared their knowledge
and allowed me to show their inspiring art.*

DEDICATION

For Jeffery and Jennifer

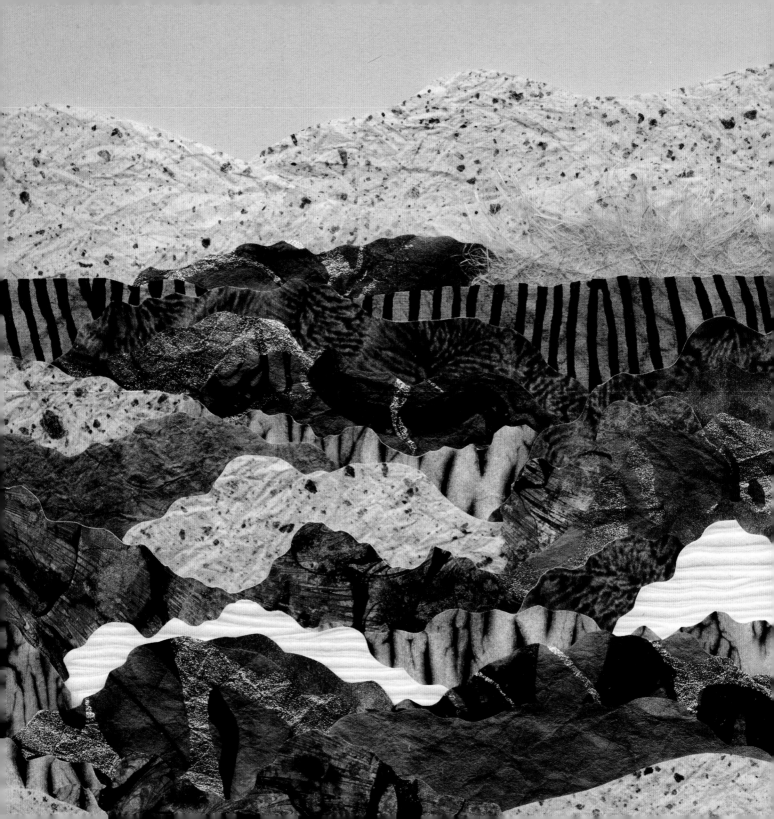

PREFACE 9

COLLAGE 13
 Basic Materials and Equipment 16
 Collage Papers 20
 Aging and Distressing 25
 Choosing Colors 29
 Creating Collage Materials 31
 Putting It All Together 52
 Learning from the Professionals 56
 Using Computers in Collage 62
 Gallery 72

ASSEMBLAGE ART 77
 Four Artists Discuss Their Work 78
 Assemblage Materials 81
 Dolls, Jewelry, Shrines, and Shadowboxes 85
 Gallery 101

ALTERED ART 105
 Altered Books 106
 Altered Clothing and Objects 123
 Gallery 138

CONTRIBUTORS 140

FURTHER READING 143

INDEX 144

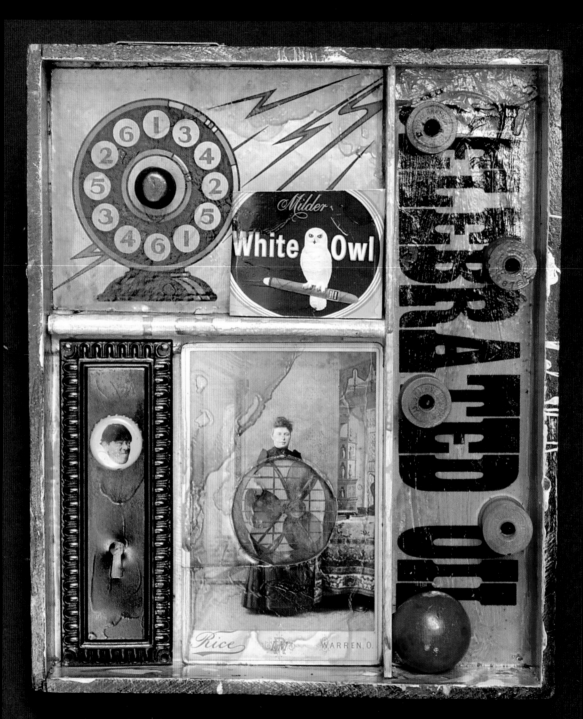

PREFACE

Traditional and nontraditional forms of collage, such as assemblage and altered art, are extremely popular today. People who once believed that they had no artistic ability because they couldn't draw are happily discovering that they may have untapped talent when it comes to creating collage. Many artists and craftspeople trained in different, more rigid mediums are also immersing themselves in various forms of collage, surrounding themselves with found papers, vintage objects, and odd pieces of rusting metal and approaching their art with a more playful attitude.

Part of the reason collage is so popular is because it is non-intimidating. Unlike drawing and painting, where each stroke is a commitment that has to be kept, collage elements can be torn off or pasted over if you don't like the way your composition is growing. There is no right or wrong way to proceed, only guidelines that can be followed if they work for you or tossed aside if you like the renegade direction in which your work is heading. This book begins with traditional paper collage and shows you how to alter found materials and create your own papers as well as how to use a computer to create collage art. Well-known artists reveal their favorite techniques and provide examples of work to inspire you.

The second section of the book deals with assemblage, sometimes called three-dimensional collage, in which everyday objects or parts of objects (usually found or discarded) are combined to create a sculptural composition or construction. This section of the book will help you find and alter assemblage materials and show you what's involved in creating assemblage art. Professional artists describe their projects, giving tips and techniques and a candid look at what inspires them. They also show how the problems that often arise during a collage project are an important part of the journey of discovery, which can lead a collage artist in a new, more interesting direction.

She Was His Biggest Fan by Robert Villamagna. The humor that permeates many of Robert's works is evident in this assemblage box.

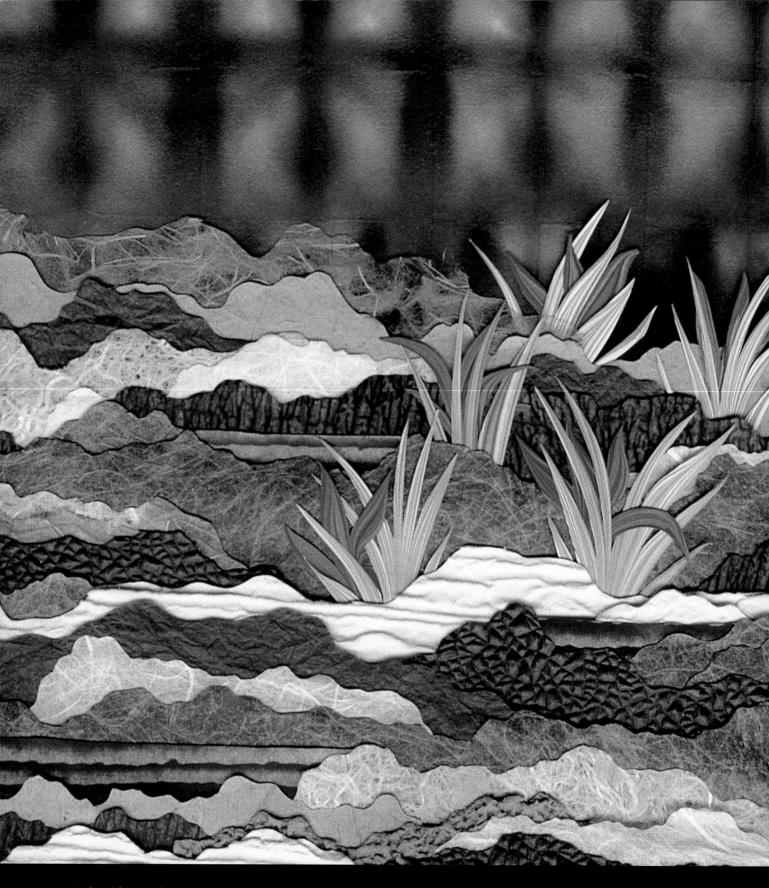

Chapel Garden by Diane Maurer-Mathison. Orizomegami, paste paper, and marbling techniques were used to create this dimensional paper collage.

Opposite: See My Meaning, *mixed-media altered vintage book with accordion fold and attached signatures by Sharon McCartney.*
Photo by John Polak.

One possible reason for the current embrace of assemblage art is that as our world becomes more technologically advanced (and we more isolated) we naturally long for the "good old days." We certainly show an increased fascination for things nostalgic. Old advertising signs, tins, glass bottles, watch parts, dials, gears, vintage toys, doll parts, board game pieces, old photographs, cigar boxes, and myriad other pieces of memorabilia are increasingly sought after. Assemblage art is increasingly visible on the Web, in art and fine craft galleries, and in art shows. Assemblage art isn't just about attaching bits of memorabilia to each other, however. Contemporary assemblage artists often amuse, chide, and tease the viewer by combining totally disparate or incongruous elements in a work or use the objects to soothe, tell a personal story in a kind of code, or imbue the objects with a whole new association and meaning.

The third section of the book focuses on altered art, taking an existing object, like a book or a woman's compact, and using collage and assemblage techniques to transform it into a piece of artwork. Found in this section are examples of avant-garde and beautiful, altered books, with pop-ups, shadowboxes, and secret compartments, as well as books that become sculptural forms. More unusual types of altered art, including clothing, musical instruments, and pencil-and-nail constructions are also presented to show you that any-thing goes when an artist with an unfettered imagination tries his hand at altered art.

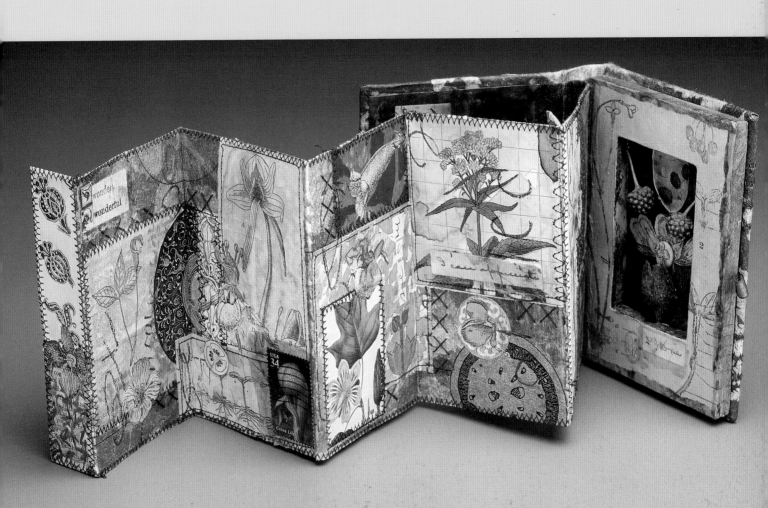

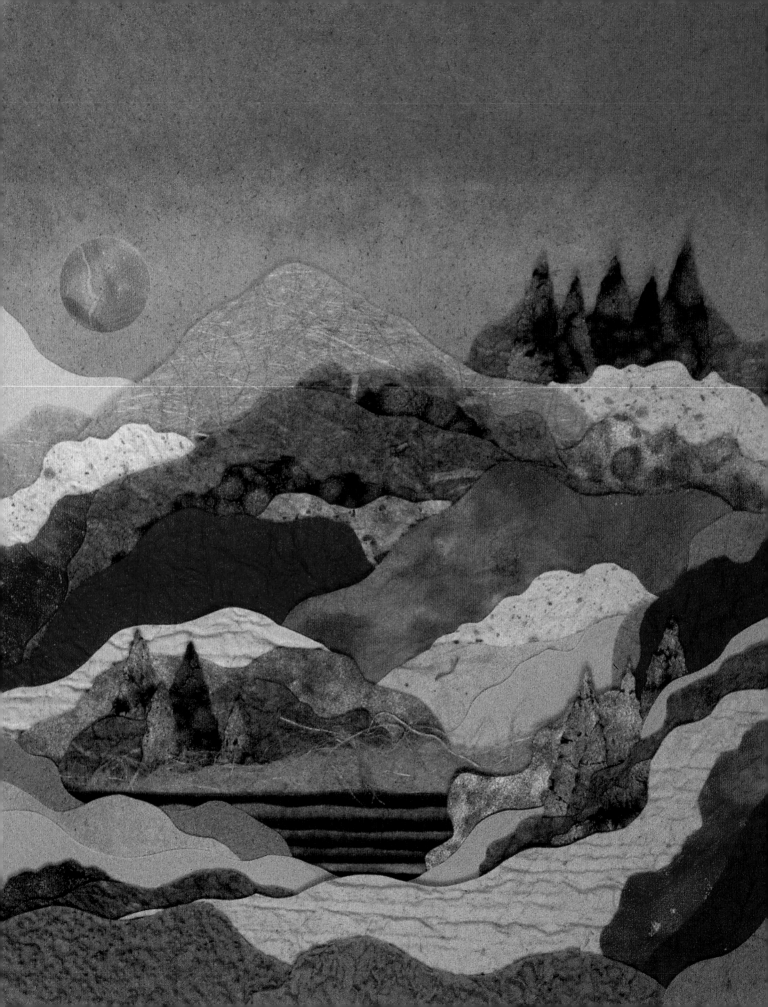

COLLAGE

Although most people associate collage—gluing materials to a surface to create a design—with nineteenth-century cubist art, collage has a much longer history. Twelfth-century Japanese calligraphers often copied poems on collaged cut, shaped, and tinted papers. Images of plants and animals were often cut from metallic papers and pasted in place to further decorate the poems. Collage was considered more a decorative ornament than an art medium, in fact, until about 1912 when Pablo Picasso and Georges Braque began pasting ephemera like scraps of wallpaper, newspaper clippings, tobacco wrappers, and matchbook covers to a support to create papier collé (the French term for pasted paper). The cubists embraced the graphic impact of collage and its ability to express ideals and ideas. Once it was recognized as a legitimate art form, other artists and art movements—the futurists, constructivists, dadaists, surrealists, abstract expressionists, etc.—adopted collage as a means of personal and political expression.

Autumn by the Creek, a paper collage of artist-made and purchased papers by Diane Maurer-Mathison.

Some contemporary collage artists create their own decorative papers for collage, but many still continue the tradition of using photos, found papers, and other societal castoffs like wire, string, bottle caps, feathers, and interesting bits of flotsam and jetsam to construct their collages. Several of the techniques that collage artists incorporate in their work today harken back to the nineteenth-century French collage artists who coined terms like *brulage* (burning or scorching work), *décollage* (partially pasting or tearing away collage), *découpage* (a collage of cut paper), *frottage* (rubbing, to create a textured paper for collage), *fumage* (creating patterns by smoking paper), and *photomontage* (using cut photographs to create a collage.) As in the past, the collage medium is a great way for an artist to communicate political and social views and to inspire, amuse, and sometimes shock the viewer.

Although some collage artists like to add drawn or painted elements to their work, as Picasso often did, drawing ability is not necessary for collage art. Artists from varied backgrounds as well as people who have no art experience can enjoy the medium without feeling intimidated by their lack of drawing skills. With a little instruction in technique and design and color basics, most everyone will be able to create a successful composition. Collage elements can be added and subtracted and moved about until they intuitively feel right for adhering in place. If you change your mind about a collage paper the next day, you can just tear it off (a la décollage) or paste another piece of ephemera over it.

The choice of materials and the way you overlap and arrange them is totally up to you. There is no right or wrong way to proceed. Your collage can be centered on a theme or it can be a playful abstract piece, unified by the repetition of a particular color or shape. Try to relax, loosen up, and have fun. Put on some favorite music, pour yourself a glass of your favorite libation, and just start moving materials around. If you really get stuck, consider following in the footsteps of twentieth-century artist Jean Arp, who designed one of his collages by letting pieces of paper fall at random to determine their position.

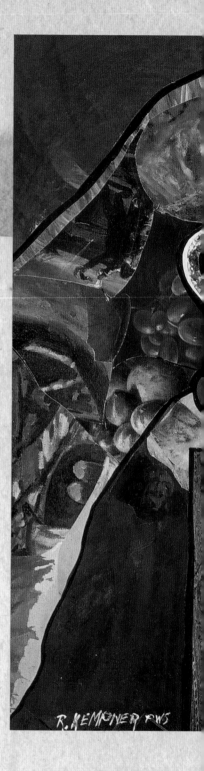

Homage to Cezanne, a magazine paper collage by Ruth Kempner. By painting the backing board for her collage black, Ruth is able to outline specific collage elements and accentuate some of the spaces left between them.

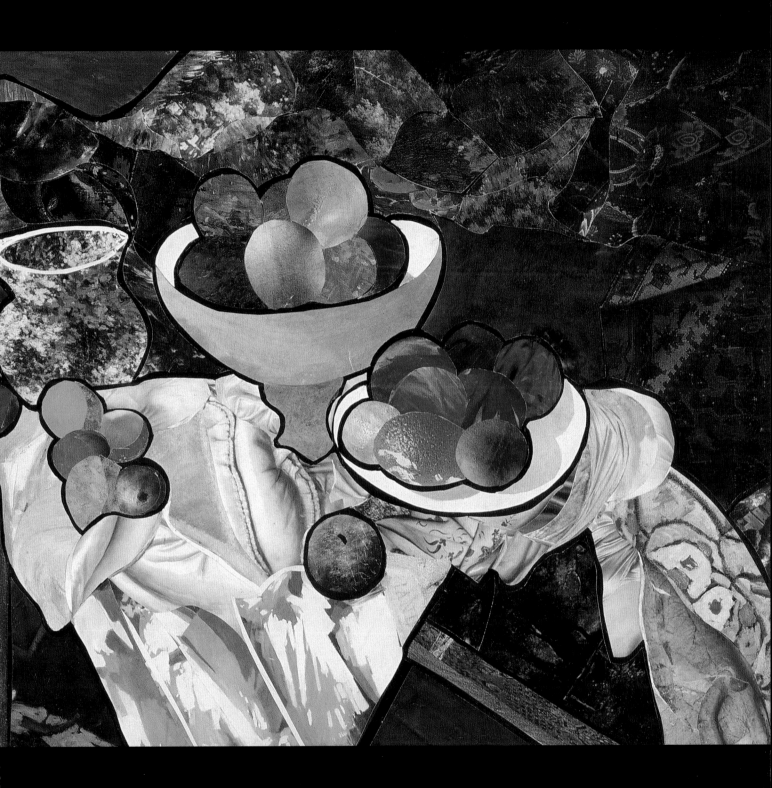

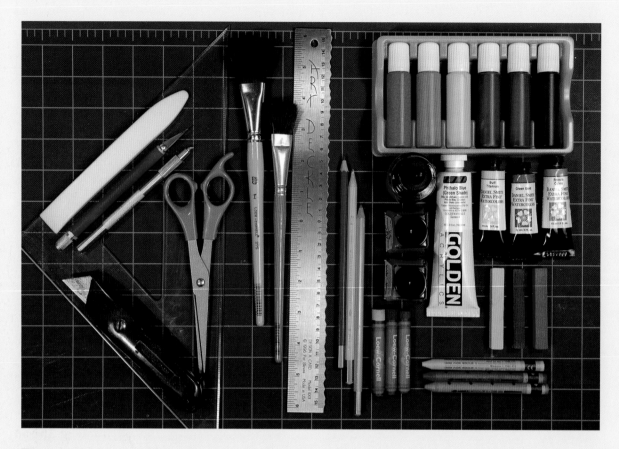

To get started in your collage adventures, you'll need the following materials and equipment:

BASIC
MATERIALS
AND
EQUIPMENT

ADHESIVES

Matte medium or gel medium can be used to glue down lightweight materials. (Many collage artists, like Ruth Kempner, also use acrylic medium to coat all of their materials, including leaves and lichen, to encase any acid bearing elements and preserve materials.) Archival PVA, polyvinyl acetate glues, can also be used in collage, although they tend to wrinkle lightweight papers. Yes! Paste won't wrinkle paper, and is not highly acidic. I use Yes! Paste in many of my collages. Other ways of attaching collage papers include using dry adhesive tapes like ATG tape and Tom Bow or sheets like Cello-Mount and Chartpak Dry Bond Adhesive. These products consist of a layer of dry adhesive sandwiched between two slippery sheets. To use the adhesive, you peel off one slippery sheet, apply your collage paper to it, and then peel off the backing and press your collage piece in place. Many of

Some of the equipment and coloring agents used in collage.

these products are repositionable, so you can change your mind about placement until the paper is burnished or rubbed down. Another option is to use a Xyron machine, which coats your paper with adhesive when you feed it through with a hand crank. If you decide to work with heavy collage elements or non-porous surfaces like metal, glass, or plastic, a stronger adhesive, like E6000, is recommended.

BONE OR TEFLON FOLDER

Papers adhered with dry adhesive will need to be rubbed or burnished in place with a bone or Teflon folder to make sure they adhere well.

BRUSHES

Various size brushes are needed for applying acrylic mediums to coat out collage supports and papers and for applying adhesives to collage materials. Brushes are also needed to apply various paints to enhance a collage surface or to carry a watercolor or ink wash to create a collage background or final coating of all materials. Large and small watercolor brushes are useful for applying water to help tear papers and give them a deckle edge.

COLORS

Various water-based paints, inks, colored pencils, and markers can be used to shade and color collage papers or parts of a collage like the exposed torn edge of a collaged sheet. Pearlescent or iridescent inks and acrylics are especially fun to use. Many collage artists have a favorite product for their signature technique. Janet Hofacker, for instance, swears by Caran D'Ache water soluble crayons, which she routinely uses as a wash to lightly tint collage paper and cloth. To use the crayons, she lays down a color and then wets a brush and goes over the color to dissolve it, blotting the wash if necessary. Michelle Bernard-Harmazinski prefers to use Adirondack Color Wash dyes to tint both paper and cloth. Instead of a wash, Elaine Langerman likes to use a heavy application of acrylic paint and varnish on her collage book panels, really "piling it on" to unify all the images and give the work texture. You'll develop your own preferences for coloring agents as you work with collage. Because collage is so popular right now, many art supply companies are producing new coloring agents especially for the collage artist.

CUTTING MAT

A self-healing cutting mat will facilitate cutting with a mat knife or X-Acto knife. Get a large mat so you don't have to keep shifting work around as you cut. Don't try to use cardboard as a cutting base; it will only dull your tools.

CUTTING TOOLS

Various types of cutting tools will be needed to prepare backing boards and collage materials for placement in a work. If you don't have a heavy-duty paper cutter or mat cutter, you'll need a mat knife and a long metal square to cut matboard or foamcore for a collage backing. For paper elements that you don't want to tear but instead give a sharp edge, large and small conventional scissors and scissors with blades that yield a decorative edge will be helpful. An X-Acto knife with sharp blades is a must. A swivel knife that can easily cut curves will also be a good addition to your tool kit. Depending on the types of images you choose to show in your collage, you may want to invest in circle cutters as well. I also use sharp, metal hole punches in my work to create the signature moons or suns that often appear in my collages.

DIGITAL CAMERA

A digital camera is helpful to a collage artist not only for taking photos to be collaged into a work, or to create a digital collage, but to record a preliminary placement of collage elements before they are permanently adhered in place. Some collage artists like to sketch out a planned design and fit elements into predetermined spaces. Others like to let their collage design grow and change as they create it piece by piece. I like to let the collage grow by some trial and error, often adjusting pieces as I work. Sometimes I just tack pieces of paper elements in place with a glue stick. At other times I'll slip papers behind each other or move them about to determine placement. Digital cameras with a large viewscreen are great for capturing your preliminary collage design and offering a quick reference before you permanently adhere elements in place. A visit from a resident kitty or a breeze from an open window won't disturb the lightweight elements and set your work day back an hour or two. You don't even have to print the photo; just refer to it in playback mode.

MISTING BOTTLE

This is helpful for delivering water to keep colors flowing when applying a watercolor or ink wash.

PAPER OR PLASTIC TO COVER WORK SURFACES

Newspaper or a heavy drop cloth would be fine, too.

RULERS

If you are cutting matboard by hand to use as a collage support, you'll need a yard-long metal straightedge or steel square to guide your mat knife. Smaller metal rulers and squares can be used to give a crisp edge to collage materials. My favorite ruler is a plastic triangle with calibrations and grids for measuring and

Cartoon Cowboy by Paul Maurer. Because his collage contains upholstery tacks, Paul affixed it to a wood backing rather than a matboard one.

squaring and the all-important metal edge, made by the C-Thru Ruler Company. Their regular rulers also have a grid and a metal edge, which makes them easier to use than the cork-backed metal rulers. Another type of ruler that will come in handy is the Art Deckle Ruler made by Design a Card, with which you can give your papers a decorative edge, resembling the deckle edge found on handmade papers. To use the tool, you simply lay it on top of your paper and, using an upward motion, divide your paper by pulling it against the serrated teeth of the ruler. On heavy papers or very fibrous ones, tearing will be easier if you lay down a line of water with a paintbrush, using the ruler as a guide, and then pull the dampened paper over the ruler teeth.

SUPPORT MATERIALS

The support paper or backing on which the collage elements are glued should be sturdy enough to support them without bending or buckling. Matboard, 140 lb. watercolor paper, foam board, binder's board, or illustration board is often used. To be absolutely certain that the support won't warp, many collage artists coat it on both sides with acrylic medium. For works that have heavier materials collaged onto them or that have tacks or brads incorporated into the piece, as in the cartoon cowboy by Paul Maurer, pictured below, using a wood backing is usually the best way to proceed.

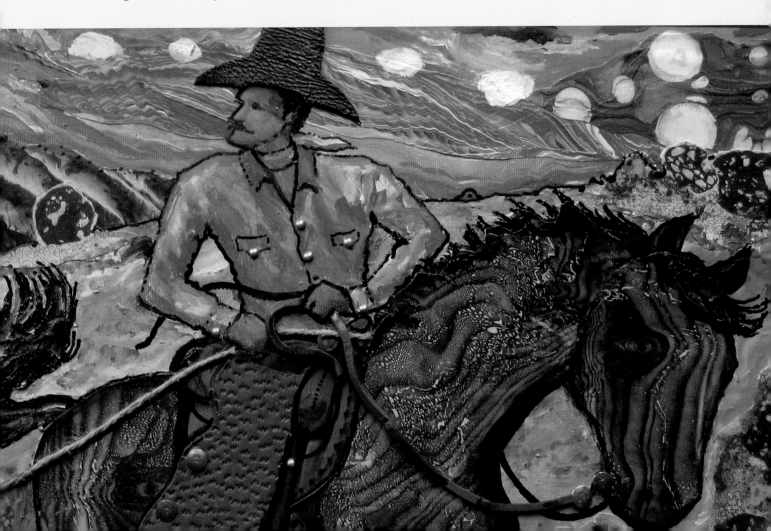

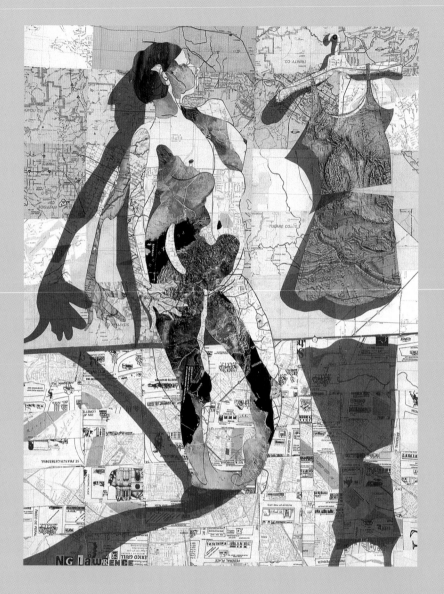

All sorts of lightweight non-paper elements can be used for collage. Seeds and seed pods, sand, stones, pieces of glass and metal, leather, pieces of fabric, string, beads, wire, watch parts, brads, nails, feathers, twigs, and fungi have all been used by collage artists. Most collage elements are made of paper, however. Papers can be found, purchased, made by hand, or altered, either by aging or distressing or by decorating with various surface design media. Photographs, whether found, rediscovered, or specifically taken to be used in a work, also make great collage elements.

COLLAGE PAPERS

Shadowdance, a map collage by Nancy Goodman Lawrence. Roadmaps and topographic maps are combined to create the figure and clothing in this work. The blue shadow areas are vellum stationery adhered over the collage. Because the vellum is transparent, the background papers can show through.

DOMESTIC FOUND PAPERS

Once you begin using found materials in your collages you'll be amazed at the many types of interesting waste papers that present themselves. We are far from a "paperless society," despite the computer age. There's a wealth of old and new found papers that can bring a collage to life. Some can be found close to home in attic trunks, scrapbooks, or your neighbor's garage sale, but other collage-worthy offerings are trappings from everyday life. Labels used as advertising on foods and wines, coupons, candy wrappers, ticket stubs, cards and letters, calendars, catalog and magazine pages, and dress patterns can all be used. So can blue prints, wallpaper, fancy napkins, take out menus, parts of books and book jackets, children's drawings, sheet music, bills, receipts, postcards, coasters, sandpaper, crepe papers, posters, prints, paper slide mounts, negatives, maps, and images and phrases downloaded from your computer.

FOREIGN FOUND PAPERS

If you travel, you'll find a wealth of fascinating paper ephemera to use in your collages. Foreign stamps and currency, of course, make colorful additions to collages. Play bills, concert programs, brochures from attractions visited, postcards, and business cards advertising tourist sites are all potential collage materials. Many countries produce amazing art on their packages and pride them-

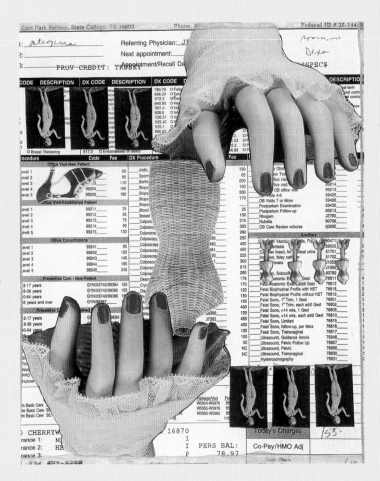

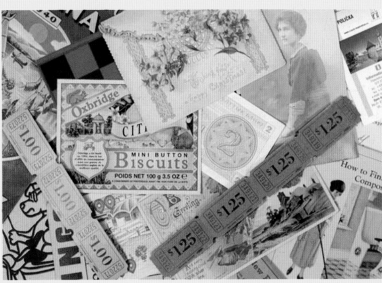

Top: Found papers, like a receipt from a doctor's visit, shown in *The Female Form I* by Alyce Ritti, make good collage materials.

An assortment of domestic and foreign found papers that might be used to enliven a collage design.

selves on the beautiful way they present their foods in boxes and in wrappings. I've bought British Oxbridge Mini Button Biscuits more than once, just for the charming illustration on the box. In Prague, free paper bags urging you to clean up after your pet are adorned with a picture of dog sitting on the throne, reading a book. The bag became quite a coup for a friend who was making a collage about her dog, Jake.

People who live in cities can find exotic papers in ethnic districts, such as Chinatown. Check some of the out-of-the-way shops in your neighborhood. I discovered recently that for several years I've had an Eastern European pastry shop a few towns away that carries candy and packaged things from Russia. It could provide many interesting collage materials. Even using a piece of a newspaper or comic section written in a foreign language can add mystique to a work.

Be careful, though. Many found papers, like newsprint, are highly acidic and tend to deteriorate quickly. If you seal them by coating them, front and back, with matte medium, you can prevent their demise. Coating papers with matte medium also renders them more fade resistant. Another option is to make photocopies of paper elements you wish to use in a collage on a neutral pH or non-acidic paper. That way you can make sure that your collage materials will last. Photocopies are also a good way to include a part of an old document or book jacket without destroying the original.

PURCHASED PAPERS

Domestic and foreign, artist-made block printed, marbled, paste painted, and batiked papers are available to collage artists worldwide. Most large art supply stores and catalogs offer hundreds of papers for you to choose from. If you Google the words "decorative papers" on your computer, you'll find many places to purchase stock. One of my favorite shops stocks over 1,500 different papers.

Some of the many domestic and imported purchased papers available to collage artists.

YOUR OWN DECORATIVE PAPERS

Instead of purchasing decorative papers, many collage artists like to make their own. Searching for just the right paper in just the right hue can take time, plus it's really rewarding to be able to say that not only have you created the collage, but you've decorated the papers that went into it. Many artists, like Claudia Lee, really start from scratch, physically making the papers as well. Although there is not room in this book to go into the papermaking process, papermaking is not difficult and is well worth pursuing via the many titles devoted to the subject. In the next chapter you'll learn some paper decorating, printmaking, and photo-transfer techniques that can give you graphic and colorful additions to your collage art.

Handmade batiked papers and Xeroxed transparencies of her grandmother's journal are among the papers Claudia Lee used to create her collage entitled *Early Morning*. Waxed linen stitching helps to highlight areas and add another layer of color.

TEXTURING AND ALTERING PAPERS

Various design elements like shape, texture, color, and line are each important in a collage work. By texturing and altering collage papers, you can increase your palette and help keep your work exciting. Tear or cut

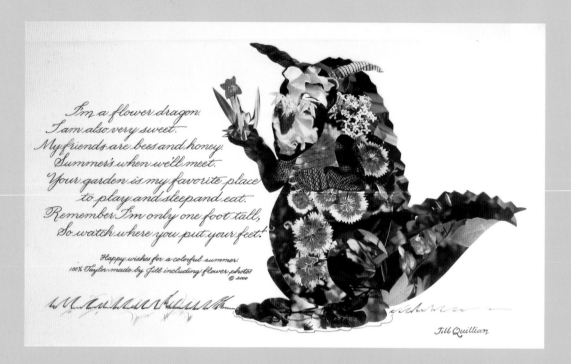

I'm a flower dragon.
I am also very sweet.
My friends are bees and honey.
Summer's when we'll meet.
Your garden is my favorite place
to play and sleep and eat.
Remember I'm only one foot tall,
So watch where you put your feet!

Happy wishes for a colorful summer
100% Taylor made by Jill including flower photos
© 2000

Jill Quillian

papers into large and small pieces, varying the shapes, making some geometric and some organic. Tear a piece of paper away from you to give it a clean but ragged edge, or tear toward you to create an edge that highlights the paper's core. Lay down a line of water with a wet brush, let the water soak in, and then pull the paper apart to create another type of deckle edge. Photos or photocopies of photos can be cut into strips or shapes and rearranged to form abstract or representational designs like the *Flower Dragon*, pictured above. Papers that have been adhered to the collage support can also be torn to create a décollaged work. Just peel back parts of papers that have been glued together and slowly rip part of the paper away.

There are many ways to give collage papers more dimension and texture. You can crumple, fold, or pleat them or weave them together. You can also roll paper into beads or tubes to create linear structures. Sometimes a predominantly horizontal collage needs a few vertical or diagonal lines to provide contrast and give it energy. I often like to wet and roll small bits of rice paper to add egg or stonelike structures to my landscape collages.

Jill Quillian's *Flower Dragon* collage and accompanying calligraphic poem were created to be used on a summer greeting sent to friends. The collage is composed of Jill's photos.

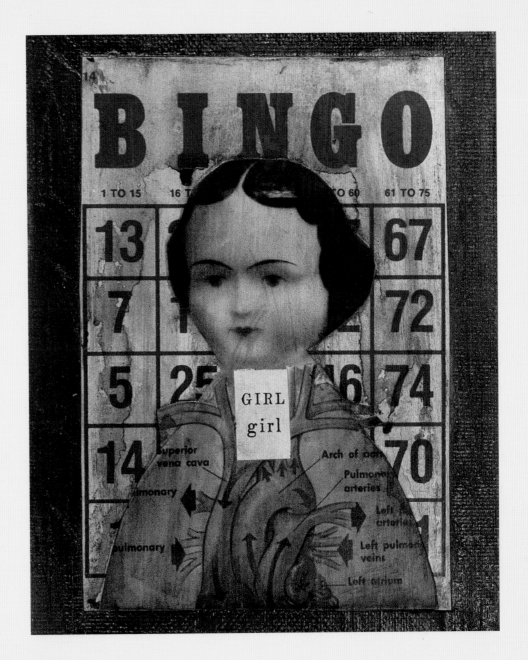

AGING AND DISTRESSING

It's a little ironic that many of the same collage artists who go out of their way to make sure that the papers they use are acid free or at least neutral pH (non-acidic) search for ways to make their collages look like they were made from papers that are old, weathered, with brown or gray mottled areas, burn holes, foxing, and other marks of deterioration. Aging and distressing papers and fabric to make them look like they are antique is extremely popular today.

Janet Hofacker used a tea wash to age the papers on her collage *Girl*.

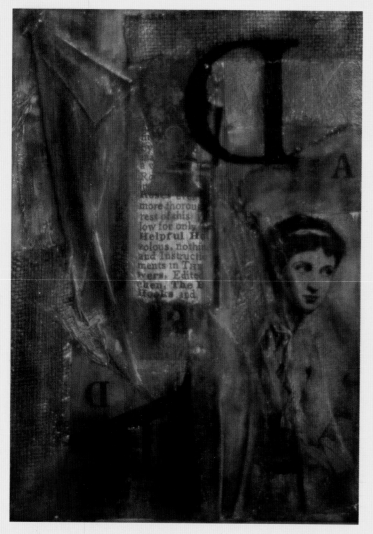

AGING COLLAGE ELEMENTS

An easy way to age collage elements, used by artists for many years, is to color them with coffee or tea. Just make a strong solution of coffee or tea and pour it into a pan. Then place your paper (or fabric) in the solution and gently move it around until it reaches the color intensity you're looking for. Splashing, spraying, spattering, or using a pipette to drop coffee or tea onto your paper will give you additional mottling on a dry or still damp soaked sheet. Lea Everse, whose collage cards often feature aged papers, suggests sprinkling instant coffee granules on a dampened, previously dyed sheet to create uneven darker areas. If you brush tea or coffee on a piece of waxed paper it will separate into tiny beads of liquid, creating a random pattern that will be transferred to paper applied to it. Janet Hofacker likes to brush an antiquing tea wash directly on her papers. She steeps three tea bags in one cup of boiling water for several minutes and then, using a 1-inch-wide brush, lays down a wash in a haphazard fashion to create interest.

Inks can also be used to create an antiquing wash to color collage materials. Walnut ink (named for the color of the ink) can be brushed on a dampened paper to give it an aged appearance. For another interesting effect, Lea suggests dropping or spraying alcohol on a sheet of paper that has been coated with a wash of brown or walnut-colored drawing ink. The spots of alcohol repel the ink and create a lovely pattern that resembles tortoise shell. Janet likes to create a translucent ink wash by first diluting her ink with water. Using a small brush, she lays down the ink wash where she chooses, controlling the value of the color by

By diluting red ink with water, Janet Hofacker created a translucent ink wash that integrated all areas of her collage *Helpful* when she brushed it on.

using more or less ink. New varieties of raised stamp pad ink with names like "peeled paint," "tea dye," "vintage photo," and "shabby shutter" can also be used to age papers, fibers, and photos by rubbing the stamp pad directly on the material in a "direct to paper" technique.

DISTRESSING COLLAGE ELEMENTS

Attached papers can be made to appear worn and weather-beaten by sanding them, after the adhesive is completely dry, with various grades of sandpaper. Go slowly, with the grain, and try sanding just the edges of the papers and/or interiors of sheets to get different effects.

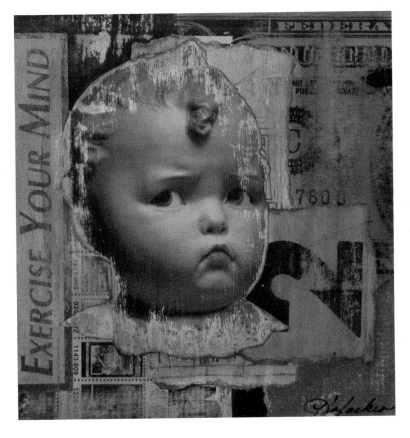

One of collage artist Janet Hofacker's favorite techniques for changing the overall feel of a collage, making it appear distressed and giving it depth is to use a technique called "dry brushing." She begins with a soft, dry brush about $1/2$ inch wide and a white or off-white acrylic paint tinted with a chosen color. (She usually uses soft peach or yellow to tint the white.) Next she dabs the brush in the paint and wipes it back and forth on a piece of scrap paper to remove almost all of the color. Then, using a sweeping motion, going with the grain of the paper, she brushes the remaining paint over the collage papers.

Grattage, the art of altering a collage by scratching away part of its surface, will also make your collage appear weathered and distressed. Various sharp implements, such as broken glass, a nail, razor blade, or a stylus, can be used to make marks and scrape away previously painted areas. Scottish artist Joanne Kaar often uses grattage to deconstruct her *Fragment Series*, pictured on page 28, collages and mirror the way in

Exercise Your Mind by Janet Hofacker. Dry-brush techniques were used to age many of the papers in this collage.

which buildings and landscapes, in a state of constant change, are torn apart and razed. She notes that, "Remnants of the past are left like scars on the landscape. Dig down into the ground, and each layer exposes a story of a moment in time." To create *Fragments # 9*, pictured on page 27, Joanne imbedded plastic shuttles used to make fishing nets, and her own stitched handmade paper, into a square of wet plaster. When the plaster was dry, she covered it with beige pastel chalks to match the color of her paper. Then she used various implements, like scissors, knives, and sewing needles, to scrape away the colored pastel and reveal the white of the plaster again.

Joanne also used an additional method of distressing paper, *brulage*, or burning, to further distress or deconstruct the papers. She burned the edges of the work as well as the area around the herringbone stitching to create what resembles worm holes in the work. Although some collage artists use a match or candle and a great deal of caution to burn their papers, Joanne prefers to use a pyrography machine or woodburning tool as it gives a much more controlled burn. Ruth Kempner often uses a candle to create brulage and *fumage*, or smoked designs, as shown, to create papers for collage use.

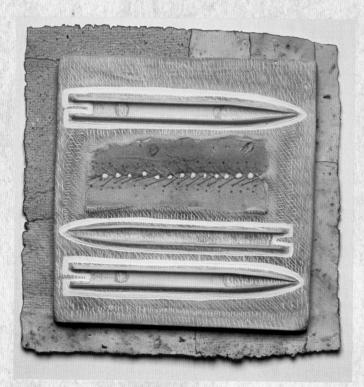

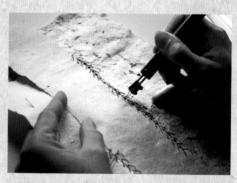

Joanne often uses a woodburning tool to burn the edges of her papers and the areas around the herringbone stitching to help them appear distressed or worm eaten.

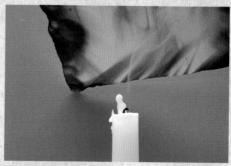

Joanne Kaar used knives, scissors, and sewing needles to scrape away part of the surface of *Fragments # 9* to deconstruct it and make it appear weathered and distressed.
Photo by Michael O'Donnell.

Fumage, or smoked designs, can be made by holding a paper over a candle that has just been extinguished. The paper pictured has also been carefully edge-burned with a match.

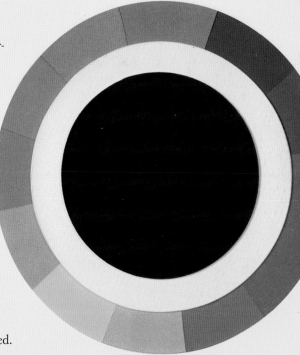

It may be helpful to study a color wheel to help you choose papers for collages that harmonize with each other and convey the mood you are trying to create. A color wheel will also help you mix paints and inks for coloring collage materials. By referring to a color wheel you can see how mixing the primary colors—red, blue, and yellow—can yield a range of other colors or hues. The three secondary colors—purple, orange, and green—are made by mixing two primaries together—for example, blue + red = purple. The six tertiary colors are made by mixing a primary color with an adjacent secondary color—for example, blue + green = blue-green. Your color palette can be further extended by changing the value of the colors, by tinting them with white to make them lighter, or by shading them with black to make them darker. When used in an artwork, dark colors will appear to recede, while lighter ones come forward and help to convey a feeling of perspective.

Something else to consider when choosing a color palette for your collage is the *temperature* of your colors. Cool, calming colors—like blue, green, and purple, which could remind one of mountains at dusk or the sea—appear to recede in a collage while warm energizing ones like red, orange, and yellow, reminiscent of flames and autumn leaves, leap forward.

COLOR PALETTES AND COLOR SCHEMES

If you feel a bit timid choosing colors for your collages or find yourself in a rut, always using the same palette of colors, experiment by using the following four harmonious color schemes:

- **Monochromatic:** To make a monochromatic color scheme, use tints and shades of a hue, such as light, medium, and dark green.
- **Analogous:** Create this type of color scheme by using hues adjacent to each other on the color wheel, such as blue, blue-green, and green.
- **Complementary:** By using one primary and the secondary color opposite it on the color wheel, like blue and orange, complementary color compositions are formed.
- Triadic: By using three colors spaced equidistant on the color wheel, like red, blue, and yellow, triadic compositions can be formed.

By referring to a color wheel you can see how mixing just the primary colors—red, yellow, and blue—can yield a range of other hues. A color palette can be further extended by tinting colors with white or shading them with black.

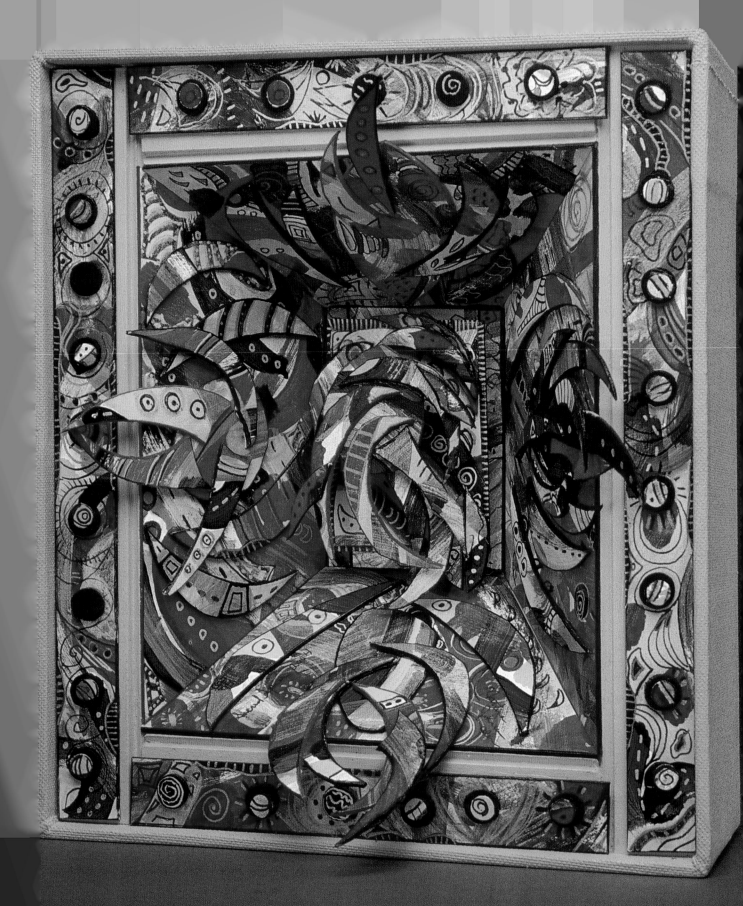

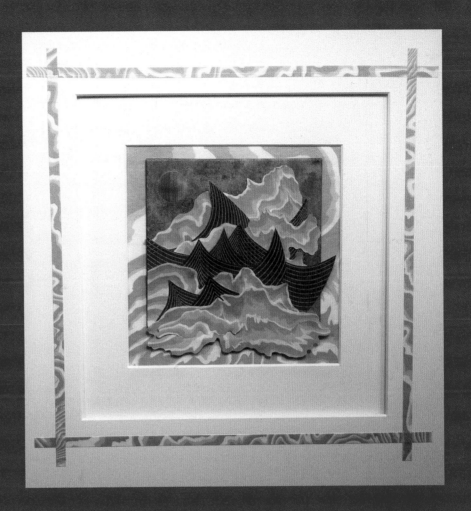

CREATING COLLAGE MATERIALS

A number of paper decorating, printmaking, and photo-transfer techniques can be used to make collage materials. A quick look at some easy techniques will get you started creating materials that will greatly increase your stash of papers and probably give you some ideas for collages. I often find that the marbled or paste paper patterns I create suggest collage themes. A series of seascape collages was inspired by a particularly spiky *suminagashi* paper I created. Many paste paper techniques can produce papers that suggest foliage, rivers, or mountains when used in a collage. Other paper decorating techniques can give you additional options. When I created a deep rich *orizomegami* paper that resembled a stained glass window I immediately thought of building a collage called *Chapel Garden*, pictured on page 10, around it.

Diane Maurer-Mathison used suminagashi marbling and paste paper techniques to create the papers used in *Sea Fever*. An arrangement of marbled paper strips, reminiscent of French matting, has been applied to the picture's mat to accent the design and lend an Asian feel to the collage.

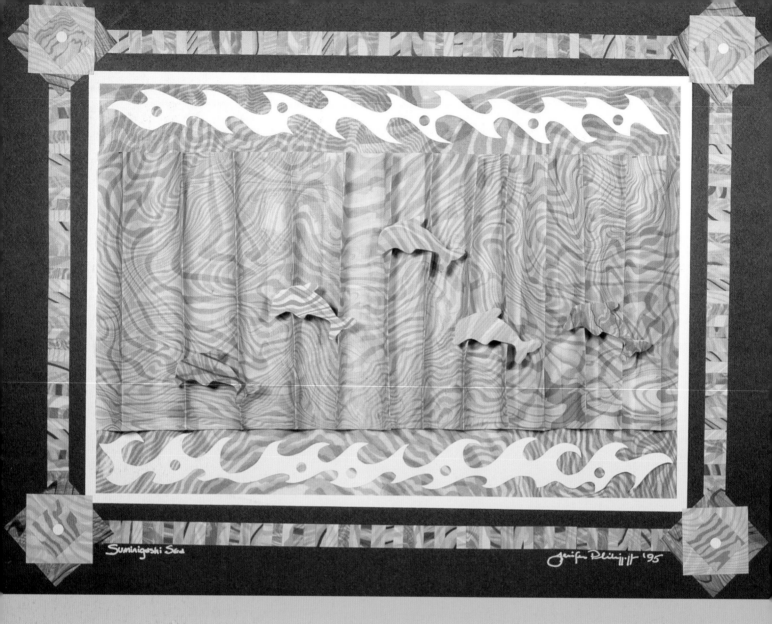

Suminagashi Sea, a collage by Jennifer Philippoff.

PROJECT: SUMINAGASHI MARBLING

Suminagashi, the oldest form of marbling, was practiced in Japan over a thousand years ago. Suminagashi techniques involve floating colors on the surface of water, gently blowing or fanning the colors into a design, and then applying an absorbent paper to make a contact print. Single-image papers with jagged or meandering lines of color can be made, or dry papers can be marbled a second time to produce a sheet with a complex pattern of intersecting lines and colors. I use single- and double-image suminagashi papers in my collages, often combining them in a single work.

Matboard-backed jumping fish and pleated waves highlight *Suminagashi Sea*, a collage by Jennifer Philippoff.

To explore suminagashi marbling you'll need the following materials and equipment:

Brushes
You'll need inexpensive bamboo brushes about an inch long and tapered to a point to apply the colors. A #4 size will be good. You'll need at least four of them.

Color containers
A shallow watercolor mixing tray or paint cups in a base that hold about a teaspoon of color are ideal for suminagashi marbling. An ice cube tray can be used as a substitute color container.

Colors
Boku Undo colors work well.

Drying equipment
Although plastic clothes-drying racks can be used to hold wet papers, the ideal setup for drying sheets is lengths of PVC pipe strung over clothesline.

Eyedroppers
These will be used to transfer color from original containers into the mixing tray when you wish to mix colors to create new hues. You'll also need an eyedropper or pipette to deposit the Photo-Flo (see below) into your teaspoon of color.

Hand protection
Thin surgical gloves or barrier hand cream can be used to protect your hands from color.

Marbling tray
A photo tray, kitty litter pan, marbling tray, or similar tray about 2 inches deep will work for suminagashi marbling.

Newspapers
Newspapers will help protect tabletops and when cut into 2-inch-wide strips can be used to skim off excess color that remains after a print is made.

Paper
Absorbent papers are necessary for suminagashi marbling. Japanese papers such as Kozo, Moriki, and Okawara, as well as Loew Cornell oriental rice paper, marble well. Handmade papers, charcoal papers, and coffee filters also work. Some computer papers with high cotton content will also pick up an image. Experiment with various kinds.

Paper rinsing supports
Most suminagashi papers will not need rinsing. Occasionally, however, some papers, most often those made with black ink, will have an excess of color that needs to be rinsed off. In that event, you'll need some sort of support to carry the wet sheet to a sink. A cookie sheet or piece of Plexiglas can be used.

Photo-Flo 200
This Kodak surfactant is added to the Boku Undo colors to help them float and spread. A solution made by mixing one drop of Photo-Flo to one teaspoon of water acts as a kind of invisible color. It pushes each circle of color it touches into a large narrow ring. The Photo-Flo solution can also be used to preserve open areas in designs.

Water

Skimming

Before you begin marbling you'll need to skim off any dust that has settled on the water in your tray and break the surface tension that sets up on the water sitting in your tray. You'll also need to skim to remove any excess color that remains on the water between prints. To skim, just drag a 2-inch strip of newspaper across the water's surface.

Adjusting Your Colors

Begin by placing a teaspoon of color in two sections of your color holder and a teaspoon of water in another section. Now add a single drop of Photo-Flo to each of the colors and to the

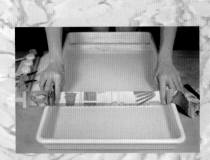

To skim off excess dust or color and to break the surface tension of the water, hold a newspaper strip as shown, and drag it down the length of the marbling tray.

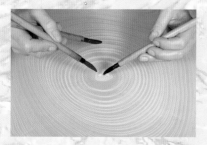

Start by holding two brushes, and alternately apply color and dispersant to build up a number of concentric rings. When you feel comfortable working with two brushes, try holding two color brushes in one hand and the dispersant brush in the other to rapidly apply color.

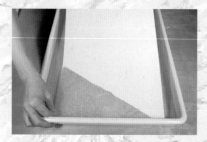

When you've made your suminagashi design, carefully lay a sheet of absorbent paper on top of it to create a contact print.

After the sheet of paper has been printed, peel it back and place it on a rinse board to rinse it with water, if necessary, or carry it to a drying area.

teaspoon of water and stir well. It's important to make sure that your color and Photo-Flo mixture is well stirred. If it isn't, the Photo-Flo will settle out and when you apply your colors, they will begin to sink. Then you'll be tempted to add more surfactant, which will, ironically, make your colors sink *even more*. (If too much Photo-Flo gets mixed into the water in your tray it will alter the surface tension so much that colors can't push against it to float.)

Applying and Patterning Colors

Start by holding two brushes, one filled with well-stirred color and the other filled with a well-stirred dispersant solution of Photo-Flo and water. Barely touch the center of the water-filled tray with a color brush, releasing a drop of color. Now touch the center of the expanded drop of color with the tip of the dispersant brush. It will propel the circle of color into a large ring. Alternately apply colors and dispersant until a number of clear and colored concentric rings are formed. Then gently blow them into a design.

If you blow from the side of the tray, the lines of color will be more meandering. A puff of air from overhead will produce a pattern with more jagged lines. You can also fan the colors with a piece of cardboard or a paper fan. Although exuberant stirring usually sinks colors floating on water, you can create subtle combed designs by dragging a single hair through the color. I created a special tool that makes interesting patterns by taping a single cat whisker to the end of dowel. (Don't trim your pet's whiskers; just be on the lookout for gifts that appear when your cat sheds them.)

When you're comfortable applying color and dispersant with two brushes, try working with three. Hold two color brushes in

one hand and the dispersant brush in the other to rapidly apply colors. Work in as many colors as you choose, creating concentric rings by alternating color with a clear ring or applying one color on top of another without using the dispersant brush. Work in the center of the tray or in various sections of the tray, building up as many rings of color as you desire for your design. You can minimize color sinkage by remembering to apply your colors gently. And if you apply your colors with just the tip of the brush and are careful not to hold the brush beneath the water's surface, you won't run the risk of diluting your stock colors by returning a water-soaked brush to them.

Note: If you intentionally hold your brush on the water's surface to deposit a large ring of color, be sure to touch your brush to a paper towel to remove the excess water before placing the brush in your color again.

Making the Print

When you've made your design, carefully lay a sheet of absorbent paper on top of it to make a contact print. Try not to shift the paper or flop it down, as you'll disturb the image you've created and possibly trap air beneath the paper, creating an unsightly void in the pattern.

One way to apply the paper is to hold it by diagonal corners so that it droops in the center: steady one hand on the far corner of the tray and, continuing to hold the paper, ease one edge onto the floating color. Then in one fluid motion, lower the rest of the sheet onto the floating color. If you're marbling very thin sheets of paper, leave the near edge of the sheet dry so you can pick the paper up without tearing it.

After the sheet has made contact with the color, lift it off and carry it to the drying area or place it on a rinse board and rinse off excess color, if necessary.

Flattening the Marbled Papers

If you place dry marbled sheets under books or a board they'll be pressed quite flat. Sheets may also be ironed on a low setting with a dry iron.

Note: When finished marbling, be sure to clean trays and brushes with water only, as any soap residue (a surfactant) will cause problems in your next marbling session.

More information about suminagashi and instructions for creating traditional watercolor marbled designs for collage work can be found in my book *The Ultimate Marbling Handbook*, available at www.dianemaurer.com.

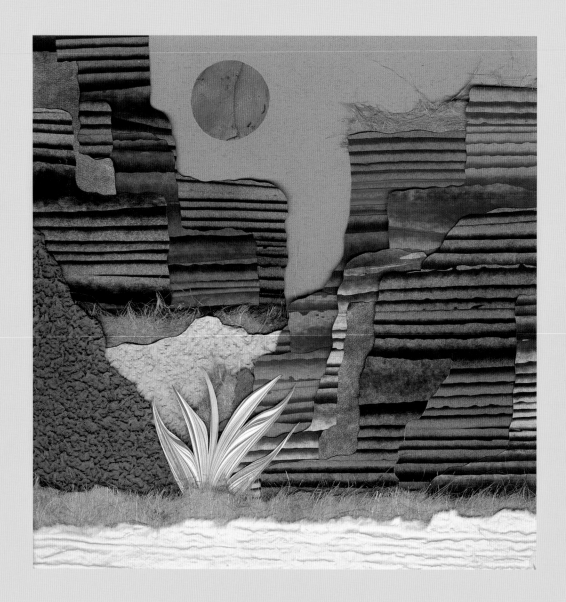

PROJECT: MAKING PASTE PAPERS

Paste papers date from around the fifteenth century. They are closely related to the finger-painted papers that we made as children, and they are just as easy to make. The basic technique involves wetting a sheet of paper, coating it with colored paste, and then drawing various implements through the paste to displace it and create patterns. Kitchen tools, hair picks, calligraphy pens, rubber graining combs, and lots of found objects can be used to make great designs in collage. I routinely create paste paper images to represent grasses, moss, rivers, mesa, and waves for my collage work.

Mesa, a paste paper collage by Diane Maurer-Mathison. Oil color and watercolor marbling techniques were also used in this work.

To begin making paste papers you'll need the following equipment:

Brushes
Several 2- to 3-inch-wide high-quality house painting brushes will be used to apply the paste.

Cooking pot
A 2-quart sauce pan will do for cooking up the paste.

Gloves (optional)

Large, fine mesh strainer

Large shallow tub
You will need a large plastic photo tray or under-the-bed storage box filled with water for wetting your papers.

Measuring cup and measuring spoons

Paints
A good brand of heavy-bodied acrylic paint, like Golden or Liquitex, will give you vibrant papers. (Don't buy the fluid acrylics, as they tend to dilute the paste.) Purchase a variety of colors and be sure to include some iridescent metallic paints.

Paper
Most nonabsorbent medium-weight papers are fine for making paste designs. The paper must be strong enough to withstand having tools drawn across it in a dampened state without shredding. I use Canson Mi-Teintes, Strathmore, and Mohawk Superfine papers, but many offset printing papers also work fine. Get a supply of colored as well as white papers. Black papers are especially attractive if they're covered with a gold or silver paste design.

Paste
Rice flour, wheat flour, cornstarch, and methyl cellulose can all be used to make paste (or starch) papers. Two recipes that I use appear below.

Paste containers
Plastic food storage containers with snap-tight lids that are large enough to accommodate your paintbrush will be ideal for holding your colored paste.

Patterning tools
Many household tools lurking in kitchen drawers and other objects residing in the family "junque" drawer, can be used to draw and stamp textural, representational, and purely decorative images in colored paste. Other great implements for making collage designs include wood-graining combs, multiple-line calligraphy pens, and potters tools. Scour your art studio for other paste painting implements, like brayers that make interesting textured papers if you roll them over a paste-covered sheet. Even corks, pieces of cardboard, and plastic milk cartons can be fashioned into paste paper stamps and combs if you cut them with an X-Acto knife or some scissors.

Sponges
These can be used for wetting the paper, making sponge prints in paste, and for cleaning off your Plexiglas work surface.

Teaspoons
These can be old garage sale items or plastic spoons. They'll be used for stirring the paint into the prepared paste.

Two small plastic water buckets
This will give you one bucket in which to dip the sponge for cleaning off your Plexiglas work surface and a second clean bucket for sponging down the paper to be pasted.

Work surface
A sheet of Plexiglas, 3 inches bigger all around than the paper you plan to pattern, is an ideal work surface.

Flour Paste Recipe

4 tablespoons rice flour

3 tablespoons wheat flour

3 cups water

$^1/_2$ teaspoon glycerin

1 teaspoon dish detergent

Blend the flours together in a saucepan with a little water. Then add the remaining water and cook the mixture over medium heat, stirring constantly, until it resembles a thin custard. Remove the paste from the heat and stir in the glycerin and detergent to keep the paste smooth and pliable. Let the paste cool and thicken before pushing it through a strainer to remove any lumps. Then divide it into containers to be colored.

Cornstarch Recipe (My favorite)

Mix $^1/_4$ cup cornstarch with $^1/_4$ cup water until well blended. Then add 1 cup water and heat the mixture while stirring until it resembles a thick custard. Finally stir in $^1/_2$ cup water to thin it. Let the mixture cool and re-thicken before use. It will be about the consistency of toothpaste when it's ready.

Note: The flour paste is a bit stiffer and more granular in texture, while the starch recipe yields a smoother patterned paper.

Coloring the Paste

Start by adding about a tablespoon of color to $^1/_2$ cup of paste. Add more or less depending on the color desired. If you want to darken a color a bit, add just a touch of black—it can easily overpower another color.

Preparing the Paper

Prepare a sheet of paper for paste painting by relaxing it in a tray of water. Just drag the paper through the water, wetting both sides, and then let it drip for a moment before carrying it over to the Plexiglas and laying it flat. Bear down as you stroke the paper with a damp sponge to remove excess water, press out any air bubbles, and completely flatten it.

Applying the Paste

Fill a 2- to 3-inch paintbrush with colored paste and brush it evenly on your paper using horizontal and then vertical strokes to cover the paper with a layer of paste. If you use different colored pastes on the same sheet, brush in one direction to avoid totally mixing the colors and making them muddy. Try letting the colored pastes overlap slightly to make subtle color blends.

Patterning Ideas

Begin patterning by drawing a tool through the paste, creating wavy or straight horizontal, vertical, or diagonal lines. Overlap designs and really get a feel for the marks your tool is capable of making. Slap your brush against the paste-covered sheet to see the marks that it leaves. Stamp into the paste with a crumpled piece of plastic wrap or newspaper, or just use the heel of your hand to make

Coating the dampened paper by brushing on an acrylic-colored paste.

interesting foliage-like designs. Objects can be coated with the same or a different colored paste or be used dry to create various effects.

You can also cut designs into a brayer and roll it over the paste-coated sheet to create a variety of images. A brayer can also be used to create designs by rolling it over a paste-covered sheet that has a rubbing plate placed below it. Press heavily pasted papers together and then pull them apart to create amazing landscape designs. The suction created causes the paste to lift into ridges resembling grasses, bushes, and trees. As you begin making designs, be sure to let yourself play. As you relax and explore the medium you'll see images emerge that lend themselves to collage work.

Multiple-Image Prints

If a dry, previously patterned sheet is dampened and coated with paste a second time, a multiple-image print can be made. Combed papers look spectacular when they're coated with a gold or silver paste and re-patterned. Be careful if you are using metal tools, however, as the re-dampened paper will be a bit fragile. ubber and plastic implements are safer to use if you intend to make double-image prints.

Preparing the Work Surface for Additional Sheets

When you've removed your first sheet to a drying area, wet a sponge in your cleanup bucket to completely remove any paste that's accumulated on your work surface before beginning another paper.

Drying the Papers

As with suminagashi, the ideal setup is to string lengths of 3-inch PVC plumbing pipe on clotheslines and drape wet papers over the plastic pipe. The papers will dry with a slight curve in the center but won't have any troublesome crimps to press out.

Creating a scalloped design in the wet paste with a rubber graining comb.

Two carved, hard rubber brayers and the patterns they yield when rolled over a paste-coated sheet.

A rubbing plate and the pattern it creates when a brayer is rolled over a paste-coated sheet placed on top of it.

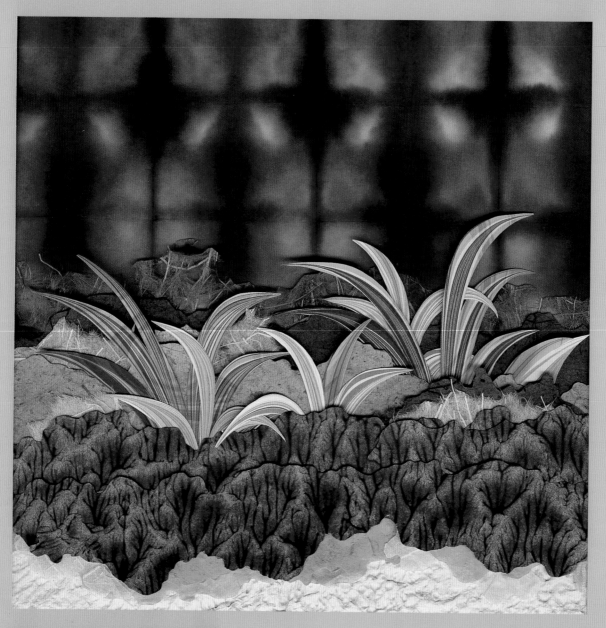

PROJECT: MAKING ORIZOMEGAMI PAPERS

The Japanese art of dyeing paper known as *orizomegami* can produce some great collage papers that evoke the image of stained glass in their luminescence. Some have such a vivid symmetry that they look like images viewed through a kaleidoscope. Although there are many folding patterns and ways to bind papers with string and board clamping, dramatic results can be achieved with a couple of basic accordion-pleating and dyeing techniques.

An orizomegami paper resembling stained glass forms the background for *Abbey Garden*, a paper collage by Diane Maurer-Mathison. Paste paper and watercolor marbling techniques were also used in this work.

You'll need:

Color and water containers
Wide-mouthed cups can hold your dyes, and the water used to moisten papers before dyeing them.

Colors
A number of types of inks and dyes can be used. Drawing inks, Boku Undo colors, fiber reactive dyes, air-brush inks and professional egg dyes are all good to use.

Hand towel and paper towels
Use these to blot papers before and after dyeing.

Newspapers

Paper
Absorbent papers. Block printing papers, handmade paper, and various types of Japanese papers like Mulberry and Sumi-e can all be used.

Plastic drop cloth
Although newspapers will absorb most of the excess color from your papers, some usually soaks through. It's a good idea to cover your work area with a plastic drop cloth just in case.

Rubber gloves

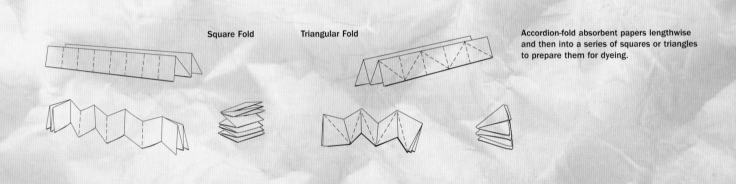

Square Fold Triangular Fold

Accordion-fold absorbent papers lengthwise and then into a series of squares or triangles to prepare them for dyeing.

Folding the Paper

You can pleat your paper in a number of ways to prepare it for dyeing. The simple hill-and-valley accordion folds are the basis for many designs and the ones I use most often in my collage work. Begin accordion pleating by folding the paper in half horizontally. Then fold each section in half again. Continue to turn your paper and fold away from you each time, creating consistent, regular folds. You can also score your paper by indenting it slightly with a bone folder or other dull-tipped tool and then gathering it up into a series of accordion folds.

Next, take the pleated bundle of paper and fold it crosswise, into a series of squares or rectangles. Another option is to fold each pleated section into a triangle. Try these simple folding patterns to create some designs that work well as background images for nature collage and great multicolored papers for general collage use.

Pre-wetting the Folded Paper

Dip the folded bundle of paper in some water to moisten it, making it especially receptive to colors. Carefully press out most of the water with your fingers and then blot it with a hand towel until it's just damp. (I like to stand on a number of bundles of moist paper, placed side-by-side inside a towel, to blot several at once.)

Dyeing the Folded Paper

Although you can pour some of your color into shallow containers and dip corners of the moist bundle of paper into the dye, you can also use dropper bottles, pipettes, and eyedroppers to dye a pleated bundle of paper. (It's sometimes easier to control color bleed by applying color with applicators than by dipping into it.) The damp paper will wick the color deep into its folds. Compress the folded bundle between your thumb and forefinger to force the dye deeper into the center of the paper, or apply pressure and blot with a paper towel to stop the progression of the dye and force the extra color out of the paper bundle.

Now apply dye to another corner of the bundle using the same or another color and repeat the procedure. When all corners of your paper bundle have been dyed and blotted, carefully open the wet paper and place it on the newspaper to dry. Try dyeing the edges rather than the corners of another pleated bundle of paper to see how that influences patterning.

Over-dyeing

You can refold a dry paper in another configuration and dye it again. Adding a few more spots of dye to a refolded sheet, or edge dyeing a paper that was previously corner-dyed, can prove rewarding.

Flattening the Papers

Although the pleated texture of many dyed papers is part of the design, you can flatten papers if you wish to. Just press the papers with a cool, dry iron to flatten them.

Dyeing a damp bundle of paper with drawing ink. Boku Undo colors and Adirondack Color Wash dyes were also used on this piece.

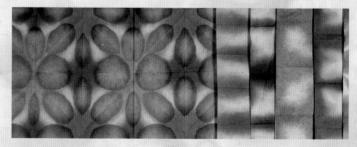

An over-dyed orizomegami paper among strips of other papers that will be used as collage materials.

EMBOSSED PAPER COLLAGE ELEMENTS

Artists working in another discipline who discover collage, of course, bring particular techniques from their previous medium into their collage work. Weavers often incorporate woven paper in their works. Papermakers bring a knowledge of embossing and papercasting that works especially well with the collage medium.

You don't have to have papermaking skills to create some spectacular collage elements, however, as you can purchase handmade paper, re-wet it, and proceed almost as though it were just pulled from the papermaking vat. Marjorie Tomchuk, in fact, lets her handmade paper dry and then rewets it to create her stunning work.

Marjorie begins by creating a kind of collage or collagraphed master plate on which to press her dampened paper. She makes the plate by sealing matboard with gesso or acrylic medium. Then she adheres dimensional pieces that are about the same thickness. Depending on the project, she'll use double-thickness matboard, rubber sheeting, small stones, bamboo skewers, and polymer clay. After all the pieces are in place, she covers everything with white acrylic gesso to make it water resistant. Soft, wet paper is then pressed into the embossing plate, either with a press or by hand with a sponge. The paper is pushed into the low-lying areas, and when it is lifted, it is embossed. Once dry, it is ready for Marjorie to collage her photos onto it.

USING PRINTMAKING TECHNIQUES

A number of simple printmaking processes like collagraph printing, rubber stamping, nature printing, salt

Marjorie's embossing plate, which is itself a collage of matboard and rubber sheeting, was covered with white gesso to make it waterproof and reusable.

Top: Marjorie Tomchuk's work, entitled *Twin Gates*, was created by collaging her photographs onto an embossed sheet of handmade paper.

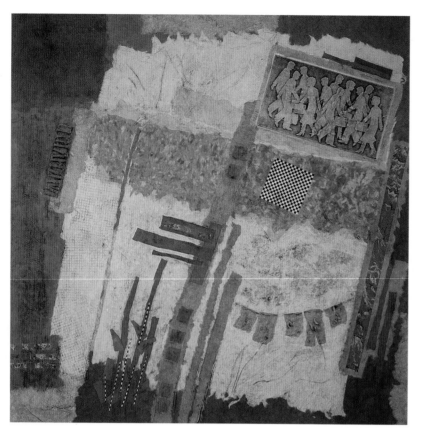

printing, and plastic wrap and fabric printing can also be used to create elements for your collages. You may have already explored some of these techniques, but it is worthwhile to take another look at them with an eye toward using them in collage projects.

COLLAGRAPH PRINTING

The same collagraph plate that Marjorie uses to create her embossings can be inked with a brayer and used to create a collagraph or collage print. The plate may be used to make a relief print by rolling ink onto its surface, or it may instead be used to make an intaglio print, by spreading the ink over the entire printing plate, filling in the shallow recessed spaces, and then wiping the ink off the raised surface. Paper is placed over the inked plate and is run through a press or printed by hand pressure on the back of the sheet with a barren or brayer to transfer the ink and make the print. Some artists are also having success creating small collagraph prints by using a pasta machine as a press. To try this, add a top sheet of matboard or cardboard to the collagraph plate and the paper being printed and hand crank the paper sandwich through the rollers of the machine.

RUBBER STAMPING

There are many commercially made rubber stamps that you can use to do all-over paper decoration or to stamp images meant to be cut out and collaged onto a work later. Images can also be stamped directly on papers or fabrics already collaged together. Any craft store or online stamp company can supply you with a multitude of images to choose from as well as stamp pads in myriad colors, including metallics.

Above: A collographed image of people rushing to and fro forms the focal point in Betsy R. Miraglia's handmade paper collage *Domestic Rituals*.

Opposite: *Into the Woods* by Ruth Kempner. Ruth used several printmaking techniques, including pressing plastic wrap, waxed paper, mesh, and bubble wrap into wet colors on watercolor paper, to create the collage background on which her cutout leaf prints were glued.

You may also want to try your hand at carving your own stamp either from your own drawing or from a traced or photocopied image transferred to a large, firm eraser or Safety-Kut.

CUTTING OUT THE DESIGN

The best tools for carving out your sketched or photocopied design are a linoleum cutter, a set of V-blades, and an X-Acto knife. Push the V-shaped linoleum cutter away from you to remove parts of the un-inked carving material, remembering to keep the printing surface level. The X-Acto knife is handy for cutting fine detailed areas and trimming away borders from the design you wish to print.

Always make sure you cut away from your image so there's enough material remaining under it to support it for repeated stamping. Work slowly, inking and stamping as you cut to make sure you're cutting deeply enough and only removing the unwanted parts.

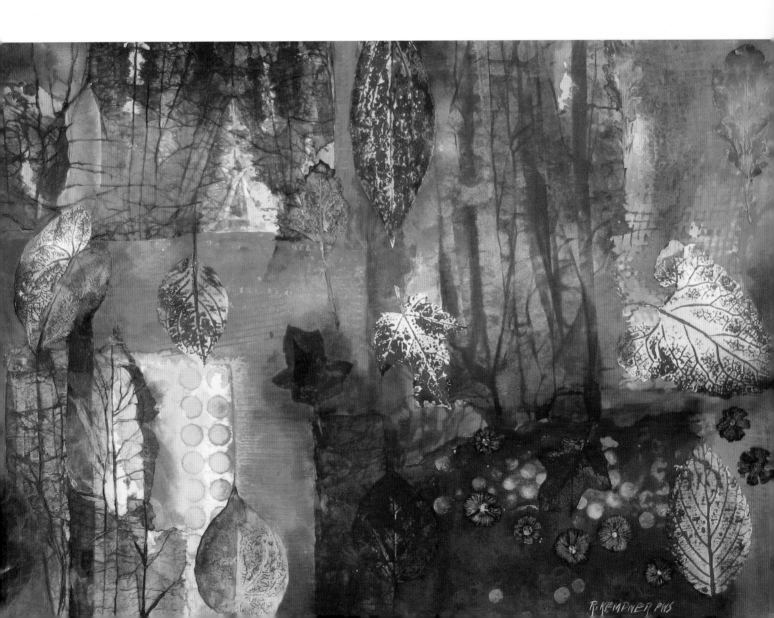

PLASTIC WRAP PRINTS

A very easy printmaking technique, particularly useful for collage (also great fun to do!), involves applying crumpled plastic wrap to wet ink or paint and weighting it with a book or board until the ink is dry. When the plastic is removed, you'll find a fractured design resembling craggy rocks or glacial ice, perfect for landscape collage. Depending on what color inks you use, the image can also represent forest growth, hot coals, or just a wonderful multicolored paper. Begin by using a foam brush or wide watercolor brush to distribute colored inks, diluted water-color, or diluted acrylic paints over the surface of a watercolor block—a stack of watercolor paper, bound on four sides—which holds wet paper flat until you pry the dried paper loose with a dull knife. (Regular watercolor paper can be used instead, but you'll have to dampen and stretch the paper before using it.) The colors should be so wet that they're forming puddles. Spray the colors with water to dilute them, if necessary, to reach this stage of wetness.

Hold your watercolor block at an angle to encourage colors to flow in a particular direction or further distribute them with a very wet foam brush. As long as the colors are wet, you can manipulate the plastic by pulling it into narrow bands or pushing down on it with your fingers to force the colors into different sections of the plastic. If you fill a pipette with ink or paint, you can also squirt colors under the plastic wrap to intermix them. When you've finished arranging the plastic, weight it with a book or board to keep it in position until the inks dry. Then peel off the plastic and enjoy the results.

A piece of crumpled plastic wrap placed on top of a piece of watercolor paper that was coated with a very wet color wash. The plastic wrap can be repositioned and arranged to create tighter or looser fractured designs.

Note: Very thin waxed paper can also be used with this technique to create interesting designs.

FABRIC AND BUBBLE WRAP PRINTS

Instead of laying plastic on your wet colors, you can also make a print by laying a piece of bubble wrap or open-weave fabric like lace, cheesecloth, or netting on the wet inks. The bubble wrap and fabric attract the inks and leave an imprint on the paper as it dries. (If using acrylics, remove any fabric while the paper is still damp. The dried acrylic can act like glue.)

Another printmaking technique to try involves gluing thick lace to a waterproofed piece of matboard to create a printing plate and then rolling over it with a paint-covered brayer. If you then place a sheet of paper on top of the inked lace and roll a clean brayer over them, the lace image will transfer.

SALT PRINTS

Still another easy way to make prints for collage use is to apply the same watery wash recommended above to a watercolor block and then sprinkle various types of salt on the wet color. As the color dries, the salt wicks the color around it to produce a mottled pattern. This technique produces beautiful textured papers for general collage use, but it is particularly good for producing papers that resemble a star-covered night sky if done in dark blue inks, or an undersea environment if done in pale blues and greens. Table salt, kosher salt, and pretzel salt, sprinkled on the wet colors, will produce star-burst patterns of various sizes. Let the ink dry before brushing off the salt.

Salt sprinkled on a watercolor paper awash in color has wicked the color and created starburst designs. The designs will vary depending on the type of salt used, how close to each other the salt granules are, and how wet the paper is.

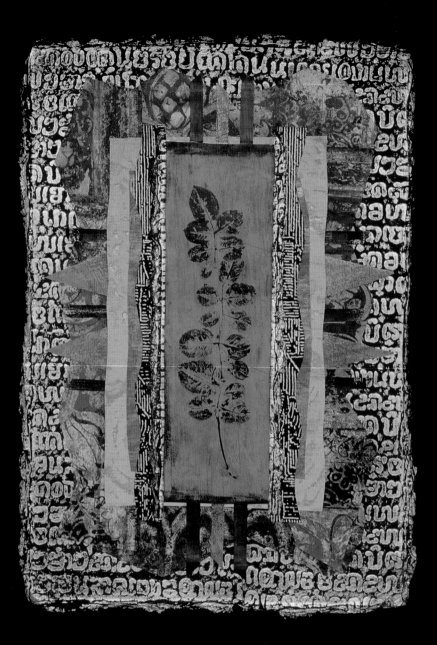

LEAF PRINTS

Leaf prints make exciting collage inclusions. Using bits of nature found in your own backyard or on a walk in the woods gives a collage a personal connection. The detailed textures of tree and plant leaves are hardly noticed most of the time, but they can be faithfully reproduced and commemorated in nature prints, where the details are revealed. You can press leaves for winter use or prune your houseplants if you live in a colder climate. Some houseplants, like my deer's foot fern, yield great prints without any pressing.

Overture, a leaf-print collage by Carole Shearer.

To explore leaf printing, you'll need:

Color applicators
Watercolor brushes, foam stamp pads, and soft rubber rollers or brayers can be used to coat the leaf with color. The brushes can be used for color mixing, too.

Inks
Water-based, oil-based, and acrylic paints can all be used to coat the leaf. Ink pads, brush markers, and Ranger's Acrylic Paint Dabbers can also be used.

Leaves
Fresh leaves with textured surfaces and veins running through them are good candidates for leaf prints. Try printing ferns, geranium leaves, maple, oak, ginkgo leaves, and any other nonpoisonous plants you have growing nearby. Avoid smooth glossy leaves; they usually print as a solid shape.

Newspaper and scrap paper
Newspapers can be used to protect working surfaces. Scrap paper will protect your fingers from ink when making the print.

Paper
Drawing paper, Oriental paper, watercolor paper, or printmaking paper will yield fine images.

Plant press
A plant press or a phone book with other heavy books atop will absorb some of the leaf's moisture and help flatten it.

Sheet of Plexiglas
This is your leaf-inking plate.

Tweezers (optional)
These will be helpful for picking up the inked leaf and placing it in position on the printing paper.

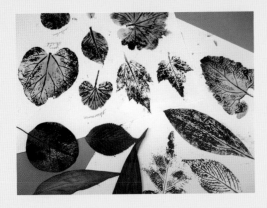

INKING THE LEAF

If you're working with a brayer, place a small amount of color on the Plexiglas and roll it out in horizontal, vertical, and diagonal directions to evenly coat the brayer. Then carefully roll the inked brayer over the flattened leaf to deposit a thin layer of color on it, highlighting the leaf's veins and textures. If using watercolor paints, or a brush marker, evenly coat the leaf, creating color blends, if desired. If using a raised foam stamp pad, press the pad against the leaf to coat it. Ruth Kempner likes to highlight the leaf's veins with black ink and then come back to add the leaf's true colors later.

MAKING THE PRINT

Use the tweezers or your fingers to gently lift the leaf and deposit it, ink-side down, on the printing paper. Cover the leaf with a piece of scrap paper and roll over it with a clean brayer.

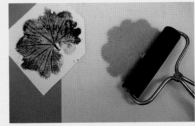

Above: Some of the leaves and the prints Ruth Kempner made from them. Ruth likes to print the leaves' veins in black ink and then paint them with watercolors to prepare them for use in her collages.

Using a brayer to roll over an inked leaf that has been placed on top of a piece of printing paper and beneath a piece of tracing paper. A colored print of a similar leaf is also shown. The colored leaf prints will eventually be cut out and glued down in one of Ruth's collages.

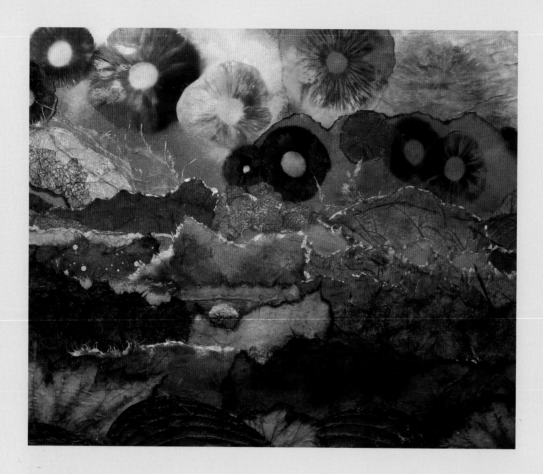

MUSHROOM PRINTS

This past spring was quite wet in Pennsylvania, and lots of mushrooms grew in our lawn, easily accessible to our dog, Molly. To determine what kinds of mushrooms we had and find out if they were poisonous, we set about making mushroom spore prints, one way of identifying mushroom varieties. It didn't take long to recognize the collage potential of the prints we made. Pennsylvania collage artist Ruth Kempner also had a good crop of mushrooms at her disposal and wasted no time in using them to produce stunning collages. To make mushroom prints, pick field mushrooms, carefully remove the stems, and place the mushrooms, gill-sides down, on paper. They will begin to drop the spores within a couple of hours. Cut around the spore prints to use as collage elements or add color to them to create more dynamic prints. (Note: If printing with unknown varieties of mushrooms, be sure to keep them away from pets and children and wash your hands after working with them.)

PHOTO TRANSFER TECHNIQUES

Lin Lacy offers three of her favorite solvent-free methods of transferring images.

Invasion by Ruth Kempner. Mushroom printing done directly on the background paper, and also cut out and pasted onto the background paper, give the work an "other-worldly" feel. Actual leaves are also collaged into the work and protected with a coating of acrylic medium.

PACKING TAPE TRANSFER: Place a piece of packing tape on a glossy magazine image. Burnish the tape down with a bone folder. Place the taped image in a tray of water and let it soak for ten minutes to soften the backing paper. Use your fingers to rub off the backing paper until just the printing ink remains on the tape. Then glue the dried image to your collage.

INK JET PRINTER TRANSFER: Tape a number of images to an $8^1/_2$ x 11-inch sheet of copy paper, allowing for a $^1/_4$-inch margin around the edges. Scan the images into your computer and mirror-image them. Print the images onto an inexpensive photo paper. Use a foam brush to wet the paper you are transferring to. (The paper should be wet but without puddles of water.) Put your photo paper facedown on the wet surface, wiping away any excess water with a paper towel. Rub the back of the photo paper with a paper towel to transfer the image.

HEAT TRANSFER: Tape your images to an $8^1/_2$ x 11-inch sheet of copy paper, making sure there is a $^1/_4$-inch margin around them. Go to a photocopy center that uses a large Canon laser copier. (Be sure to make a *laser* copy; Xerox copies will only transfer with solvent.) Ask the photocopy clerk to bump up all of the colors and mirror-image your sheet of pictures. After your images are printed, cut them out and place them facedown on the paper or fabric you've chosen to receive them. Iron the images with a hot, dry iron, using considerable pressure. To remove the photocopy paper, pull it up against the iron as the image is transferred. (Cooled transfers will cling to the paper.) This technique works with both color and black-and-white images. Since it is permanent, you can color over it with either wet or dry techniques.

A collaged page from Lin Lacy's altered dictionary featuring a heat-transferred image.

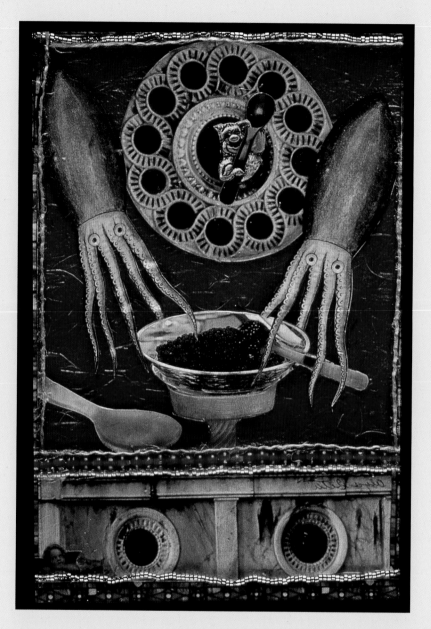

PUTTING IT ALL TOGETHER

There are no rigid rules for creating a collage design. It can be a simple abstract work created with few papers or a complex work with many layers of overlapping collage elements. Some collages are meant to be humorous; others are meant to be confrontational. Still others are enigmatic, meant to express thoughts or feelings, or to depict images from a fantasy world, commemorate a time or place, or be purely decorative, enjoyed for their beauty alone.

Gluttony II, a mixed-media collage by Alyce Ritti. Alyce's use of jewelry, beads, fabric, and ribbon enhances the surrealism of her images.

CREATING A FIRST COLLAGE

One way to begin a collage is to let your intuition guide you as you move elements around on your backing board. Position papers without adhering them at first to get a feeling for what seems to work, and what doesn't. That way you can experiment by moving materials to different positions on top of or beside other

A magazine paper collage by James Erikson. James uses interior decorating magazines as the paper source for his painterly abstract collages. His almost seamless scissor-cut constructions focus on light and space.

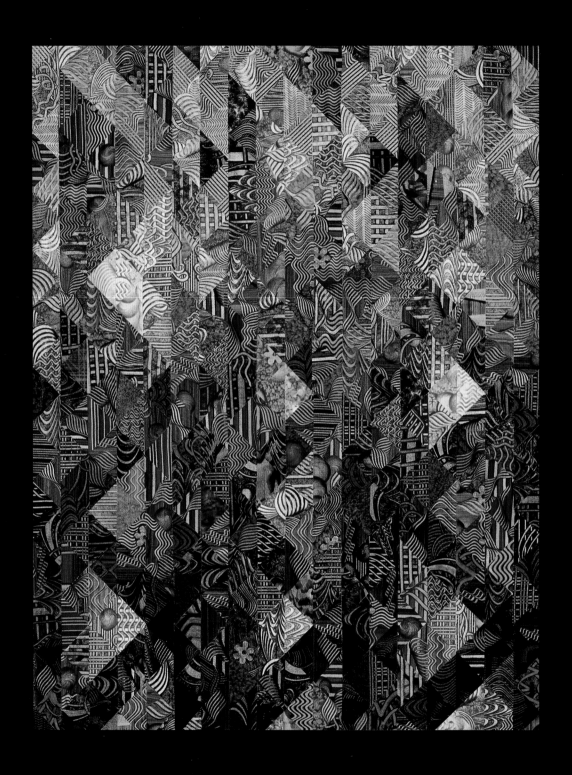

Angel Fish, a paste paper collage by Victoria Hall, features stylized fish swimming from left to right and right to left in rows. The blue and green background of the work is lighter toward the top of the collage and darker toward the bottom to suggest shallow and deep water.

elements. Notice how the colors change in intensity or seem to "snap" when placed over certain colors and become flat or die when placed over others, especially those with the same intensity. Rotate papers to see how horizontal or vertical structures would affect your composition. If it feels more comfortable, begin with the safety of symmetrical compositions at first, but also experiment with more energetic asymmetrical ones, too. Repeat shapes and color to unify elements of your collage, and keep a viewer's eye moving throughout a piece, but offer some contrast (horizontal lines in a vertical piece, an unexpected rough texture, or a flash of intense color) to keep the work from becoming boring.

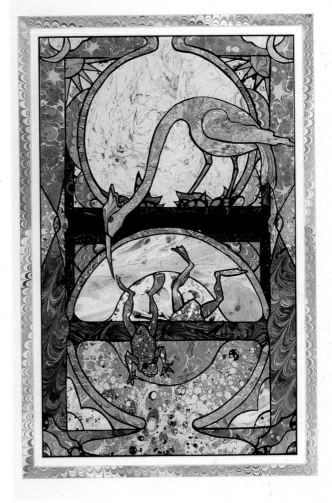

Often, students new to collage worry that their first collages will be an unsuccessful mass of papers without any focus. Working with a dominant element that the rest of the design is built around or working with just a few colors at first will usually prevent this from happening. Even strictly monochromatic collages, in which light and dark values of a single color are played against each other, are often very successful.

Another idea to get you started is to render a scene you may have photographed or recreate a piece you may have executed in another medium in collage. The intricate cut-paper collage *Window of Vulnerability*, by Nelle Tresselt, is a copy, in her marbled paper, of a stained glass piece Nelle did. Even a previous exposure to another medium may help direct you to an area of collage in which you feel more comfortable. Victoria Hall's wonderful patchwork collages show how a childhood influenced by her mother's love of patchwork sewing, and Victoria's own penchant for attending contemporary quilting exhibitions, affected her art. As Victoria says, "I knew at an early age that paper and paste appealed more than needle and thread, so the paper collage patchworks are logical developments of very early influences."

Nelle Tresselt's *Window of Vulnerability* is a cut paper version of one of her stained glass pieces. The black outline that separates parts of the image is also created with cut paper.

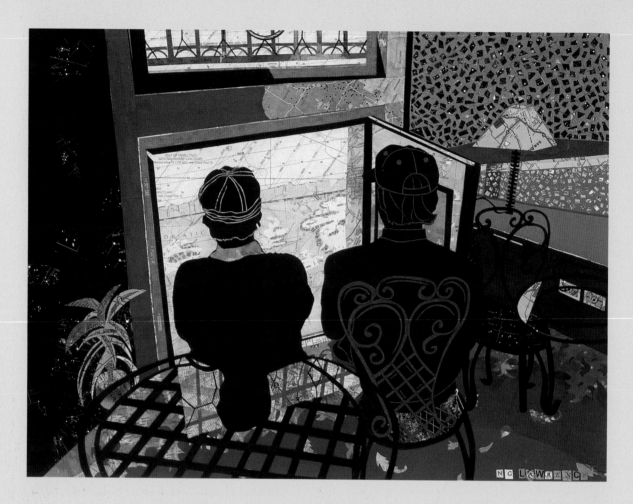

Visit museums and galleries to see collage works or browse through books at your library or bookstore to see good collage design. There are also many Web sites, like www.collageart.org, that will give you a link to collage workshops and collage artists' Web sites. If you Google the word *collage,* you'll be led to many interesting sites. Some of the collage artists whose works are shown in this book can also offer valuable insight into how they approach various types of collage.

NANCY GOODMAN LAWRENCE'S MAP COLLAGES

Nancy Goodman Lawrence's extensive use of maps in her amazing collages began quite accidentally when she happened upon a box of maps while cleaning out her parents' apartment. She had used a map in a previous collage and liked the result, so the windfall was all she needed to propel her into using maps as a

Nancy's challenge in her collage *Canal Gazing* was to convincingly recreate the two light sources that existed in her hotel room above the Venice Canal. She used many tiny pieces of paper to duplicate the quality of the lamp light in the darkened room and the outdoor light coming through the windowed door of the boat dock that opened from the floor.

primary medium. She notes that her tools are very simple: tracing paper, carbon paper, pencil, scissors, X-Acto knife, matte medium, and brushes. Sometimes there is trial and error involved in building a collage, but she avoids much of that by tacking up collage pieces with pushpins before she adheres them to the support paper. This allows her to view the placement of an element before making a commitment.

She describes her work and working methods: "Drawing is always the basis for my collages. I work from photographs of family and friends or from drawings of a live model, which I then place into imagined settings. The maps have an interesting way of picking up on the contours of the face and figure.

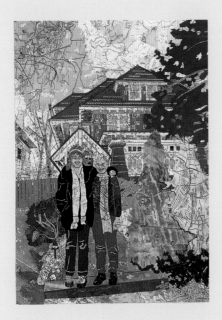

"I work on Arches 140 lb. cold-pressed watercolor paper, which I tack onto the wall. I carefully draw my subject with pencil. I then cover the drawing with tracing paper and trace it. I remove the tracing paper, and I now have two drawings—one on the main support and one on the tracing paper. I place the traced drawing on a drafting table and work back and forth between the tracing and the collage. The tracing paper allows me to slide map pieces and other papers under the drawing to see how they will translate to the collage.

"For example, I choose a section of a map that I wish to represent a particular area of the collage, such as the pine tree in *The Pittsburgh House*. I slide the map piece under the pine tree on the tracing paper drawing and position it to my liking. Next, I place a piece of carbon paper between the tracing paper and the map and carefully draw the tree. I cut around it and tack it to the corresponding place on my support paper. I continue this process until the support paper is completely covered. This is the basis from which I build up the collage. I then work back into the collage, adding layers until it is finished. I liken the process to a watercolor in that the layers are built up over an initial wash. Sometimes I allow the drawn lines to stay visible or go over them with pencil or ink to enhance them.

"I enjoy incorporating light into my work. My challenge in *Canal Gazing* was to imbue the scene with two light sources, one from outdoors and the other from a small lamp. This is an extension of painting for me and reinforces the notion that I am really 'painting with paper.' Making art is a form of play for me. I'm not that different from a child experimenting with building blocks; the process is simply more sophisticated."

The Pittsburgh House by Nancy Goodman Lawrence. This intricate collage is a portrait of Nancy and her daughter in front of Nancy's childhood home. The collage is created with various types of maps and archival art papers adhered to a watercolor support with acrylic matte medium.

ALYCE RITTI'S MIXED-MEDIA PAPER COLLAGE

Alyce Ritti's collages incorporate found papers and objects. She sees her work as putting together ordinary materials in unusual ways to create compressed "theatrical scenes" that present the "human comedy." She describes her work: "My art-making strategy simply must be to construct order out of chaos. To make collages, I sit at a table surrounded by heaps of all kinds of materials, only some of which are 'art stuff.' Cutting and pasting, stitching, and various other means of affixing occur with cutouts of all kinds, pieces of paper and fabric, photos and medical forms, actual objects such as feathers, tickets, beads, bits of jewelry, shells, straw, and buttons.

"I use quality-paper catalogs, magazines, ads, and brochures. I copy any poor quality paper onto rag paper. I sometimes go to flea markets. It is surprising how strange and interesting 'quotidian' things can be when out of their normal context."

In creating her collages, Alyce finds that usually the concept comes first and she composes the scene as she creates the collage. She usually works in a series to carry out a theme. One series, *The Seven Deadly Sins,* includes *Pride, Gluttony,* and *Sloth,* with *Sloth* featuring a turkey lolling in a hammock ignoring the sundial.

Sloth II by Alyce Ritti. Alyce's inspiration for her mixed-media collages comes from the "clash and clatter" of daily life.

"In the U.S., wasting time is a sin, is it not?" Alyce asks. In her *Sins* series, she often uses plucked turkeys as torsos for the main characters to satirically represent some of the "turkeys" she has known. Alyce notes, "My tiny collages almost always turn out to be rather funny, no matter what I intend. My deep sense of the absurd surfaces as a comic spirit that wanders through the thicket of modern life." She remembers with delight a rather bizarre guest book entry at a show of her collages: "I love your work. Really crazy stuff. But I don't think I would like you. Fred."

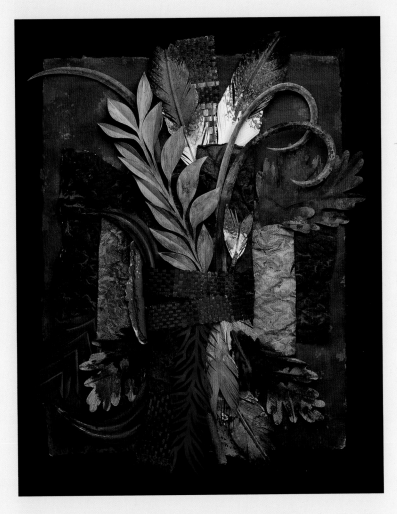

LEO MONAHAN'S ARTIST DECORATED PAPER SCULPTURE COLLAGE

Paper sculptor Leo Monahan brings layers of paper-sculpted and woven elements together in his lush collages, using whatever paper seems appropriate for the effect he is trying to achieve. On the work shown left, Leo began by sponging red and orange acrylic paint on 300-lb. watercolor paper to create an underpainting. Then, various metallics, mainly rusts, were sponged on top of the red. Leo describes the rest of his process: "The leather-looking paper is two-ply Strathmore, natural finish. I soak and crush the paper and wring it out. Then I add various acrylic colors and squeeze it almost dry. The paper-sculpted leaves, feathers, horns, etc., are drawn with a knife, not a pencil, then colored in many ways—airbrush, brush, sponge, mono print, anything to get an effect. Usually there are several layers of different mediums to get the old, textured look that I desire. I don't work with a plan. I select elements from my large inventory of all the things I have made and then assemble the collage in the most natural, symbiotic method."

A paper sculpture collage by Leo F. Monahan. Like many collage artists, Leo likes to surround himself with many materials when he begins creating a work. He creates paper sculpted leaves, feathers, and horns by the dozens and selects elements from his large inventory of pieces when he assembles a collage.

CLAUDIA LEE'S STITCHED PAPER COLLAGE

To paper maker Claudia Lee, creating her own art materials for her collages is paramount. My works begin with a base of handmade paper. I then do a wax resist/batik process on the paper.

"The batik that I do is a pretty loose process, since my goal is to lay down shapes and overlays of color. I use mostly bee's wax, although sometimes I mix it with paraffin. I work like a production factory. Using 1- to 3-inch paintbrushes, I apply wax to a dozen or so sheets of my handmade paper (50 percent flax, 50 percent abaca). Then, using spray bottles of water and pigment, I spray on several colors and let them dry. Iron and repeat. Nothing fancy. These papers will be the foundation papers. I also have boxes of decorative papers that I've made, some leftover scraps from other projects. Nothing is too small. Often the shapes and images caused by the batik process will be interesting enough to be a featured part of the piece, and sometimes I'll lay some other papers, often in shapes I've cut, on the foundation sheet.

"The writing that I use in the work is important to me and is something I've been using in my work for about twelve years. It's a page from my grandmother's journal of an ocean voyage, in her hand. Using her writing in my work feels very much like collaboration and has become almost a trademark in my work.

Top: *Untitled* by Claudia Lee. Claudia's vibrantly colored collages are constructed with her handmade and batiked papers. Hand stitching plays an important part in her work by highlighting areas, providing texture, and adding additional color to each piece.

A detail of *Untitled* focusing on the stitching, which is hammered flat to integrate more with the work.

"I Xerox all the pages of her journal on transparencies and then I Xerox them or Gocco print them onto my handmade papers. I like to work with transparencies because I can layer images, text, photographs, etc.

"Once all the parts are in place, I begin stitching. The stitches play a large part in the pieces. They highlight areas, and they provide definition, texture, and another layer of color. Also, I think there is something about stitches that evokes emotions and that connection to textiles. At least it's evocative for me. I lightly hammer the stitches so that instead of 'standing up' on the surface of the paper, they are more a part of the paper."

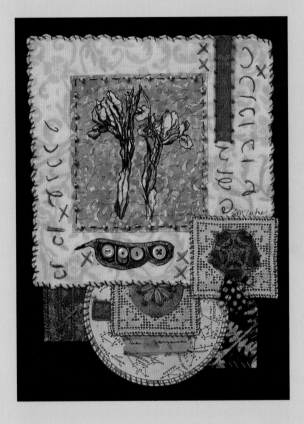

SHARON MCCARTNEY'S MIXED-MEDIA FIBER COLLAGE

Sharon McCartney's love of nature and antiquity is beautifully apparent in her stunning fiber collages. She explains how she approaches her art: "Most artists I know are avid collectors, and the tokens and objects that line their studio shelves represent shapes, colors, textures, patterns, and subjects, which inevitably turn up in their art. I am a passionate gatherer of natural objects—stones, shells, abandoned nests, pods, feathers, and bits of wood. For living things, there are photographs and drawings, ways in which I can hold onto the birds that amaze me, or the ephemeral wildflowers I love that appear each spring. I also stockpile old books, letters, handkerchiefs, doilies, stamps, bits of lace, and other embellishments. These collections are the basis of my vocabulary.

"I work with a wealth of media—watercolor, acrylic, hand-printed papers, graphite, gesso, fabric, stitching, and natural and vintage found materials. Embellishment with embroidery and beading further enriches the surfaces. The conceptual and physical use of layering and collage is integral to my work. My process is one of adding and subtracting forms, images, patterns, lines, and areas of color to produce a sense of history within each piece. The fragments are taken out of their original context to provide new meanings. Layering is used to reflect actual encounters with the natural world wherein collected views, flashes of detail, areas of various activity, and superimposed images all pass through one's senses to form experiences."

Be Joyous, a mixed-media fiber collage by Sharon McCartney. Sharon's work on vintage linen contains pencil drawings, solvent transfers, hand-printed papers, fragments from vintage letters, drawings from botany and zoology books, hand stitching, buttons, beads, embroidery, and feathers. Photograph by John Polak.

USING
COMPUTERS
IN COLLAGE

Many collage artists are using their computers to assist them in creating their art. Instead of photocopying antique photos and documents to preserve the originals, it is now common practice to scan them, perhaps altering their color to give them sepia tones in keeping with a vintage theme. Words and letters or collaged labels, like the one for the altered cigar box used in *Voodoo Doll*, pictured on page 132, can be generated in any size, color, or typeface in a simple word-processing program, printed out and cut to size to be collaged into a work.

A digital collage by Patricia Sargent. Patricia's collage was created to use as a poster for a Duke Robillard DVD release party at the Blackstone River Theatre. The collage contains digital photographs and scanned magazine images, which were resized and manipulated on the computer.

Some artists are embracing digital collage—scanning images and objects and then using a computer program called Photoshop to resize, alter, and manipulate them in myriad ways before collaging them together on screen. The digital collage by Patricia Sargent, opposite, is a good example. Other artists shy away from computer-generated art, enjoying the smell of the paint, tactile sensation of the collage materials, and the experience of working with bits of paper and a smorgasbord other materials spread out in front of them.

Book #11, En/Unfolding by Elaine Langerman. Elaine's book features collaged pages comprising cut-out computer-generated images and thick layers of acrylic paint. The book uses the idea of layering (from implied to physical) and folding as a way to symbolize things both seen and unseen.

Elaine Langerman has found a way to use her computer to create images and still enjoy some traditional collage techniques by printing the images, cutting them out individually, and collaging them back together in layers. She explains how she created the pages for her collaged game board book, pictured on page 63: "I assemble the images I wish to use, either from a library of images I've built up over the last few years, which live on my computer, or in my library of CDs. Many times I encounter new images from magazines or other publications, which I then scan in. With these images, I make a composition, sometimes repeating an image, changing its size, its color, or simply using a fragment. (Sometimes I place animal heads on human beings, for example.) After the image is composed to the exact size I want, I duplicate it and begin to create 'pull-aparts,' in which I pull apart the images so that I may construct the finished book pages in layers.

"After I print out all the various parts, I cut them out and begin to put the page together, both front and back. The borders of each page are made stiff by laminating the printed layer onto a cut-to-size layer made of heavy Japanese paper." After the page is assembled, Elaine applies thick layers of acrylic paint, giving it considerable texture and unifying all parts of the collage.

DIGITAL COLLAGE VS. DIGITAL MONTAGE

The terms *digital collage* and *digital montage* are often used interchangeably. There is a difference however. Digital collage often combines photography with graphic design and text. In addition, the photographs that make up the collage have distinct outlines. The photographs in montage (another form of collage) have no such outlines but are seamlessly blended together. In montage, the fact that the images shown could not exist together in real life is often the only way to discern that you are not looking at a photograph of an actual scene.

The best way to learn about digital collage and digital montage is to work with a computer program and study a book like *Photoshop Collage Techniques,* by Gregory Cosmo Haun. Seeing step-by-step how an artist like my husband, Jeff Mathison, went about creating his photomontage *Lake Evening* will give you an idea of what kinds of images can be made with a computer and good image-editing software. Here's an inside look at Jeff's creative process.

Choices, a digital collage by Richard Salley. Richard used stock photos and a photograph of his kitchen fork, which he copied and manipulated in Photoshop by pasting the forks to separate layers. He then rotated and resized them to create the illusion of depth. Texture was added to the road to make the surface appear more irregular.

PROJECT:

THE LAKE EVENING

MONTAGE,

BY JEFF MATHISON

"For my *Lake Evening* montage, I used Photoshop 7, with a Wacom digital tablet that can be used in place of a mouse, making selecting and masking tasks feel as natural as working with a brush or pen. Photoshop can actually create highly complex artwork starting from a white screen, if you're familiar enough with its painting tools. Most of the time, though, you'll want to start with a scanned or imported digital image. For this demonstration, I began with a photo of a calm lake on a fall day, which made a nice backdrop for the idea I had in mind. I changed the image size to $8^{1}/_{2}$ x 11 inches, with 240 pixels per inch, which I knew would yield a good print. To preserve the original photo, I resaved the file as a separate document in the Photoshop format (.psd).

The completed photomontage.

"The next major element of the montage was a bedstead that I had shot on film several years before. (Think of photos, both film and digital, as your tubes of paint. Go ahead and take plenty of shots of clouds, grasses, bricks, animals—whatever you think you might use in a montage someday. Bricks, for instance, might not even be recognizable in your final picture, but a little of their texture might show through something else, adding a bit of mystery.) I scanned this snapshot-size photo at 600 pixels per inch, knowing that when I added it to the lake image at 240 ppi, the bedstead would automatically enlarge to roughly match the size of the lake scene.

A digital photo of a smooth lake provided the backdrop for the montage.

"I used the Lasso tool to start selecting the bed frame. When I'm selecting a complex object like this, I make a quick loop around it with the lasso. Then I add any parts I missed to the selection by holding down the Shift key. I also used the Option key (Windows: Alt key) to subtract areas, like the spaces between the iron rods, from the overall selection. With both the window showing the lake scene and the window showing the bedstead open, I switched back to the Arrow tool to click and drag the lassoed selection into the lake window.

The Image Size dialog box is the place to modify pixels per inch and the overall size of the document.

"Next I clicked on the Mask icon at the bottom of the Layers palette to add a layer mask. In Photoshop, each new element becomes a separate layer, like a new layer of paper in a traditional collage. You can manipulate the color, opacity, size, texture, etc. of each layer without affecting other elements. By adding a mask you may hide or remove parts of the layer you're working on. Using the layer mask tool is my favorite way to remove extraneous background. In Photoshop, there are a lot of ways to accomplish a particular task, but I find that the more 'automatic' tools like the Background Eraser or the Magic Wand usually leave the edge of my selection too coarse, or with too many spots to fix.

A photo of an iron bedstead was digitized by scanning it.

After a rough selection, the bedstead was dragged into the lake picture.

Using the Layers palette to add a layer mask to the bedstead.

A small brush cursor is useful for removing background in tight spaces.

The iron bedstead is now cleaned up.

"With the bedstead layer's mask selected in the Layer palette, I chose a small size on the Brush tool, set my Navigator view to 200%, and proceeded to simply scrub away the meadow around the bed frame. Note that in Mask mode, the color chips on the toolbar change to black and white. When the black is in front, it indicates that I'm removing, or hiding, pixels on that layer. If I slip with the brush and remove something I want to keep, I flip the color chips to put the white in front, and I will then be replacing the lost area. (Another good key command to remember is simply pressing x, to flip from the black chip to the white.) From this point, it was just a matter of scrubbing away until I was left with a smooth outline of the metal bed and a bit of meadow framed by the headboard.

"Next, I wanted to add a bit of drama with a photo of a fire. After scanning it, I made the entire image a layer by double-clicking on Background in the Layers palette. I used the Background Eraser tool to eliminate most of the surrounding pixels. I used the Lasso tool to round up most of the stray bits and pressed the Delete key. I added a layer mask, as I did for the bedstead, and used the Brush tool to clean up the edges of the flames. In some spots, I set the brush at 50% opacity to leave a more nuanced edge.

"With that masking completed, I dragged the fire image into the lake window. To put the fire image behind the bedstead image, I clicked the new layer in the Layers palette to select it and dragged the new layer's name below that of the bedstead layer. I then clicked on Edit > Transform to bring up the Transform box. I shrank the fire and rotated it slightly to match the angle of the iron bedstead. I used the Lasso tool to select the flames that hung below the metal bed frame and pressed Delete to remove them.

"A flea market box lot of antique photos yielded this shot of newlyweds. They seemed to belong to the same era as the bedstead. After scanning the photo, I dragged the image into the lake window, placed it over the "For Sale" placard on the headboard, scaled it down, and rotated it using the Transform tool. For a soft transition from the photo to the sale sign, I added a layer mask to work on the sign. I used a larger size brush (about 45), at 50% opacity to grade the edges into the placard.

"I decided the image needed to suggest a little more about the couple. I liked the way a park pavilion's reflection is just barely visible at the upper left of the water. I hunted around for a country farmhouse that looked like it could have been the couple's and took a photo of it to use in the montage. Even though I expected it to be quite small in the montage, some of the modern clutter on the porch bothered me. So I cleaned it up with the Clone tool, which looks like a little rubber stamp. The idea of this tool is to first Option/click (Windows: Alt/click) on an area that you would like to sample. Then, when you paint with the tool, it repeats, or clones, the area that you clicked on over the area you want to alter. I sampled bricks, bushes, and other bits to replace the chair and motorcycle. Don't you wish you could clean up your whole house that way!

"After dragging most of the house and yard into the lake window, I brought up the Transform tool. I scaled the house down to 40% and rotated it 180 degrees so that it would appear as a reflection in the lake. After a bit of thought, I turned it a few more degrees to the right to match the shoreline and shrank it some more as well.

"At this point, I needed to remove the sky from behind the inverted house. I used the Magic Wand tool to select a few

The original shot of a fire was scanned into the computer.

The background eraser tool left a lot of unwanted bits around the flames.

Using the Brush tool on a layer mask cleaned up the fire.

Placing the fire behind the headboard.

The scan of an antique wedding photo.

Blending the edges of the wedding photo.

A country house that was chosen to complete the background.

The clutter on the porch.

sample parts of the sky and then chose Select > Similar from the menu bar to select the rest of the sky. While holding the Option (Windows: Alt) key, I used the Lasso tool to deselect bits of the house's window and other bright pixels that the Similar command had gathered by mistake. When the selection looked right, I pressed Delete.

"Then I added a mask to the house layer. I used a small brush to remove a few remaining pixels of sky color. Next, I used a larger brush at 50% opacity to streak through the branches a bit, to add to the illusion that they were reflected on water. I applied that mask, by clicking and dragging the layer mask thumbnail to the palette trash can. I clicked on Apply when a dialog box asked if that was what I intended. I added a second mask to the inverted house. I used the Gradient tool and dragged from just the beach to the porch roof to create a gradual transition. It took numerous tries before I got the look I wanted. Remember that you can try different approaches, and simply hit Command-z (Windows: Control-z) for a quick undo. I applied the second mask and then experimented with blending modes (the popup menu on the Layers palette), until I settled on Hard Light at 75% opacity. That gave the house a nice transparency. Finally, I added a little motion blur (Filter > Blur > Motion Blur), to give the house a slightly rippled effect.

"A white bench on the beach didn't seem to belong in the picture, so I chose the Background layer, turned off the house layer so I could see better, and cloned some of the beach to replace the bench. To wrap up the project, I double-checked for flaws in the masking and then applied all the masks. If I think I might ever want to go back and rework any montage, I save a copy in .psd format, which preserves all the layers but makes

for a very large file. Usually, I consider the montage completed, flatten all the layers, which melds them into one, and save the image in .tif format."

AN OVERVIEW OF PHOTOSHOP AND A FEW NOTES FROM JEFF

Any discussion of digital collaging and montaging must center on Adobe Photoshop. For editing, altering, and downright mooshing pixels around, it can't be beat. Several other good image-editing programs are available, including Paint Shop Pro (Windows only) and Corel Painter, which is especially good for painterly effects. But when I want to montage, Photoshop is the tool I launch. The professional version, now known as Photoshop CS, is the best choice, but it is expensive. Adobe Photoshop Elements, a home version of the professional program, has many of the same tools and functions for much less money.

COPYRIGHT ISSUES

Collage artists who intend to show their work or offer it for sale need to be aware of copyright issues so that they are not sued for plagiarism. Although works published before 1923 are generally considered in the public domain and OK to use, it is best to contact a copyright lawyer to get a professional opinion and interpretation of the rather difficult to understand laws governing "fair use" of even small sections of others works. It is always safest to use photos that you have taken yourself, or visit online sites such as istockphoto.com or Gimp-Savvy.com, where thousands of vintage maps, photos, and labels in the public domain can be downloaded and used in your work. A good discussion about copyright for collage artists in laypersons' terms can be found online at www.funnystrange.com.

A much cleaner porch.

Selecting the sky with the Magic Wand tool.

Streaking the branches to blend them with the water.

The Blur dialog box.

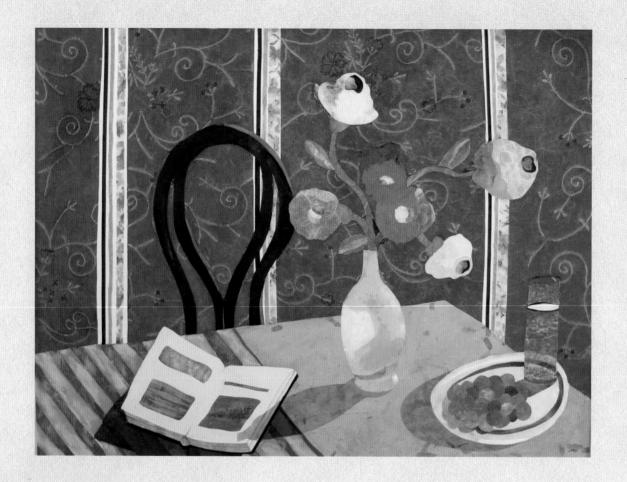

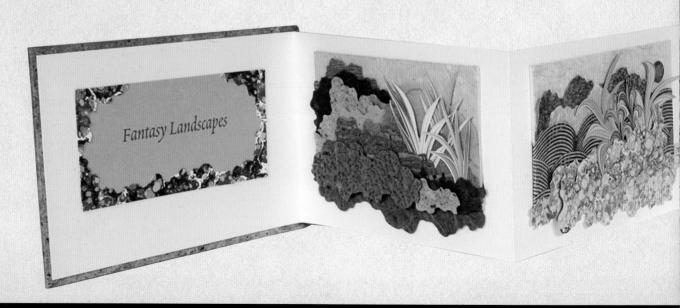

Fantasy Landscapes

Homage to Matisse, a collage of purchased and hand-painted rice paper by Ruth Kempner.

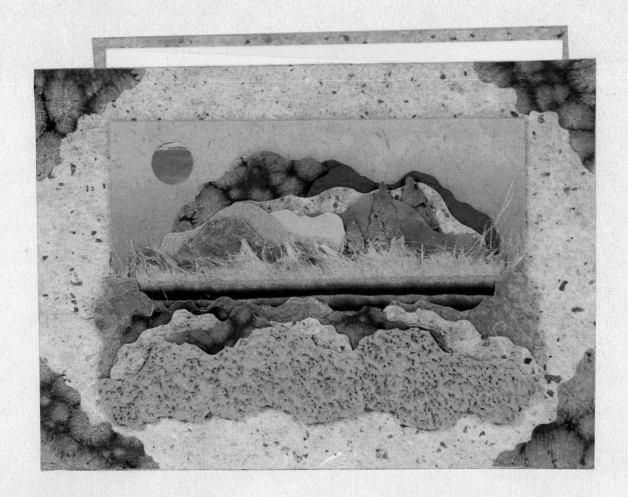

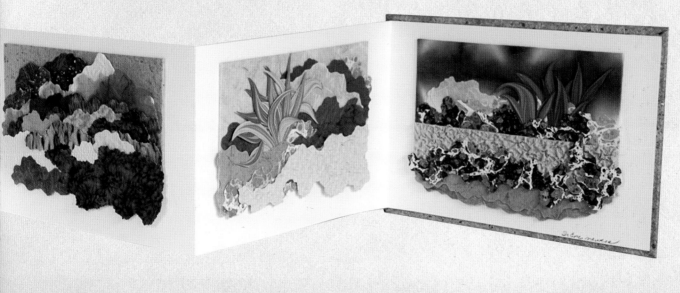

Top: The cover of *Fantasy Landscapes.*

Fantasy Landscapes, a six-panel accordion-fold artist's book featuring miniature collages by Diane Maurer-Mathison.

Above: *Blossom*, a collage of stitched handmade and commercial papers on a wood panel by Jennifer Morrow. Photo by Ken Woisard.

Opposite: *Effects. Sleep. René Magritte Takes a Dip*, a magazine paper collage by George Sargent.

ASSEMBLAGE ART

Assemblage art, often described as found-object art or three-dimensional collage, involves using everyday objects, both natural and manmade, to create a sculptural composition or construction. If the objects are old, rusted, weathered, or incongruous, so much the better. Using societal castoffs in assemblage art has a long history in works by Dada artists like Marcel Duchamp and Kurt Schwitters and later in the early '40s by Joseph Cornell, whose boxed assemblages created a new way to present the art. The fact that using found and discarded objects fits well into a contemporary interest in recycling may be part of the reason it is so well accepted today, but recycling is certainly not the driving force behind most assemblage artists' work.

Mountain House, an assemblage by Robert Villamagna. Robert nailed old sheet metal from vintage dollhouses to board to create this work. Metal pieces depicting mountains were scavenged from a collection of old Boy Scout popcorn tins.

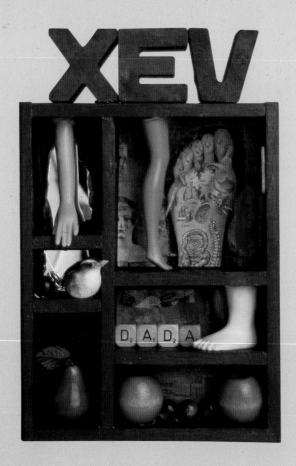

Janet Hofacker sees her art as breathing "new life into discarded remnants so that they can be appreciated and revered in ways they never were in their previous lives as common objects." She strives to give her assemblage objects a new identity and combine them so that their original function is no longer evident. To Janet, each fragment used in her assemblage art is like a player on a stage and has its own unique story to tell. Creating intuitively, Janet says that her assemblages naturally develop as they are brought together piece by piece.

Opie O'Brien describes his assemblage art: "I collect odd things, unusual things, broken things, and forgotten things—things from the human experience, which is key for me when it comes to creating, as my goal is to evoke an emotional response. I choose to work with organic, recycled, and found materials, as the pairing of these objects in particular seems to strike a cord in many people that touches their soul." An accomplished musician, Opie notes that his approach to assemblage art is "structured and disciplined" because he creates art from a musician's aesthetic.

XEV, an assemblage box by Janet Hofacker, pays homage to Joseph Cornell and the Dadaists.

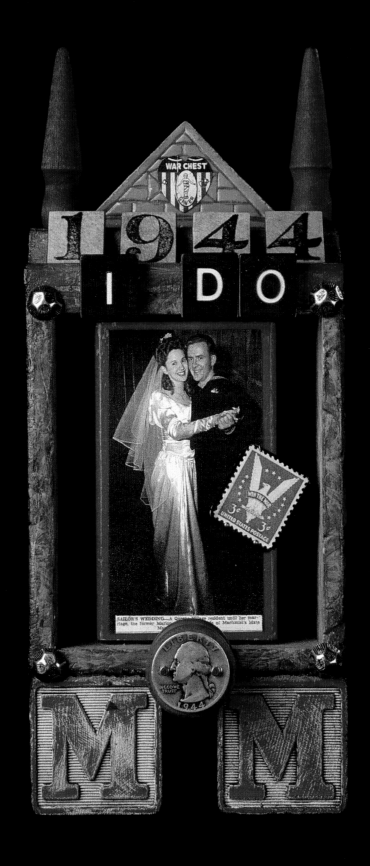

A Sailor's Wedding by Opie and Linda O'Brien. An old broken box, vintage building blocks, keys from a typewriter rescued from the trash, and assorted vintage game pieces compose this work, in memory of Opie's parents on their wedding day.

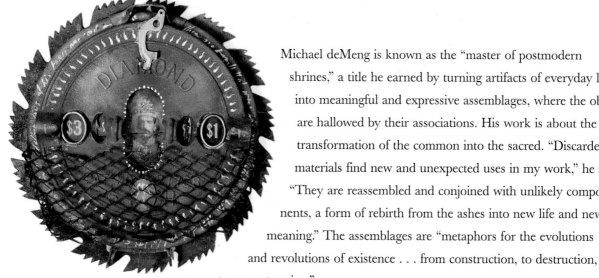

Michael deMeng is known as the "master of postmodern shrines," a title he earned by turning artifacts of everyday life into meaningful and expressive assemblages, where the objects are hallowed by their associations. His work is about the transformation of the common into the sacred. "Discarded materials find new and unexpected uses in my work," he says. "They are reassembled and conjoined with unlikely components, a form of rebirth from the ashes into new life and new meaning." The assemblages are "metaphors for the evolutions and revolutions of existence . . . from construction, to destruction, to reconstruction."

Michael likes to surround himself with lots of "junk," as he calls it. It's the initial shape or form of something that usually inspires him, and then he builds on top of it. Sometimes the end result is totally different from his original concept, as he is moved in new directions by "just the right piece that's hanging around the workshop." He moves things out of his workshop as quickly as possible because he gets tempted to cannibalize a finished work to use in a new assemblage.

Robert Villamagna's thought-provoking, enigmatic, and often humorous compositions have their roots in his own life experiences as well as stories or feelings that the found objects themselves might suggest. An assemblage artist for over eighteen years, Robert still

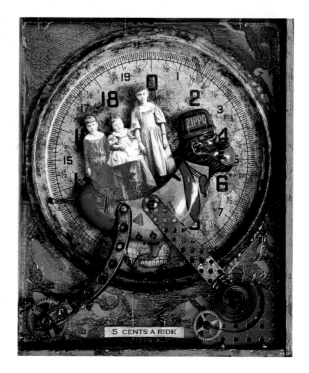

loves working with found materials, especially those items that show wear and rust and have character. He notes, " I wonder about the person who made these materials, who used them, who held them. I like to think that a part of the soul or the energy of that person is still contained in these things, and now it's transferred into the artwork. I'm giving that old piece of metal or that broken toy a new life, a different life. These various materials are every bit as much my palette as is a tray of oils for a painter."

Above left: *Diamond in the Rough.* Stove and saw parts mingle with vintage cash register keys and an eerie photograph in this assemblage by Michael deMeng.

Above right: *Five Cents a Ride,* by Robert Villamagna. Robert gave a tin monkey from an old windup toy, legs from a vintage erector set, in this homage to the old amusement park rides he enjoyed as a child.

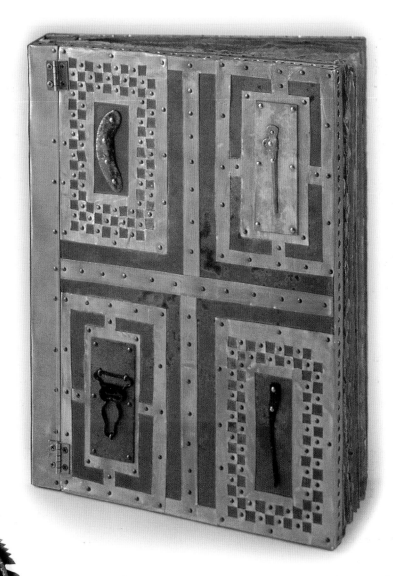

Many of the same venues that have proven to be good sources for paper and fabric ephemera used in collage work will also be a good source of supplies for your assemblage art. Attics, junk shops, garage sales, hardware stores, estate sales, and swap meets will all have things to offer.

Antique stores often have broken tin toys, jewelry, old puzzles, games, wooden blocks, license plates, opticians' lenses, advertising and political memorabilia, keys, old wooden advertising boxes, tramp art frames, printers' blocks, and printers' type that can be used. Thrift shops will have less expensive offerings. Marbles, figurines, old silverware, buttons, playing cards, tools, doll parts, dominos, baseball cards, eyeglasses, old sewing and weaving notions, old tin potato chip cans, and cookie tins are fairly easy to find. Another place to find amazing offbeat items perfect for assemblage art is eBay.

The assemblage art on the cover of Peter Madden's artist's book *Ireland Journal* showcases small found objects he found in the Irish countryside.

Think about disassembling broken objects like typewriters, toasters, hairdryers, and fans to use their components. Ask for your worn parts back when household items are being repaired. A recent faucet repair yielded a strange ball-shaped piece of metal with interestingly shaped holes that my husband immediately scooped up for his collection of assemblage parts. Be on the lookout for old washers, screws, springs, bottle caps, and pieces of metal as you walk along city streets. In the country, look for old woodland dumpsites. They often contain old advertising tins and crockery shards in addition to antique bottles. Even the smallest mundane found objects can be successfully used as embellishment in assemblage works. The assemblage cover of Peter Madden's *Ireland Journal*, pictured on page 81, a nod to the books from the Middle Ages, features a recycled copper cover with pierced lithography plates that showcase such small found-metal pieces. Natural found objects like animal skulls, sticks, shells, rocks, feathers, fish bones, bird nests, and snake-skins can also be used in assemblage. Once people realize that you are interested in making art from found objects, you'll no doubt be inundated with lots of old and (mostly) interesting assemblage elements. People love discovering oddball treasures for their eccentric artist friends.

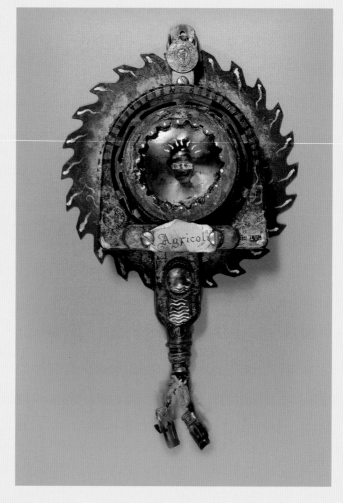

ALTERING FOUND MATERIALS

Many of the same aging and distressing methods previously mentioned for use on collage materials can be used on assemblage elements. A former painter, Robert Villamagna routinely uses acrylic, oil, and enamel paints as well as oil sticks to add additional character to his works. Michael deMeng's background as a painter also serves him well as he artfully disguises many of the joins, and even plastic elements, in his works with acrylic paint so flawlessly that you would swear they are old, weathered, and rusted areas of larger iron objects. Janet Hofacker uses dry-brush techniques and grattage to age her

Saw a Blueman is part of a series of mandalas that Michael deMeng made. He began using saw blades in his assemblage art because he found a "kitschy quality" in their use that reminded him of "all those painted saw blades you see with little scenes on them."

shadow boxes, but many artists go beyond grattage to alter their wooden boxes and beat the wood with chains or burn them. Problem solving to determine the best way to make an assemblage element look old is part of the fun of creating. To age a wooden spandrel of his assemblage box, Jeff Mathison sprayed brown and gray paint into the air and let it fall on parts of the work. To increase the weathered appearance, he then rubbed dirt into the crevices. As with all art, "whatever works" is key.

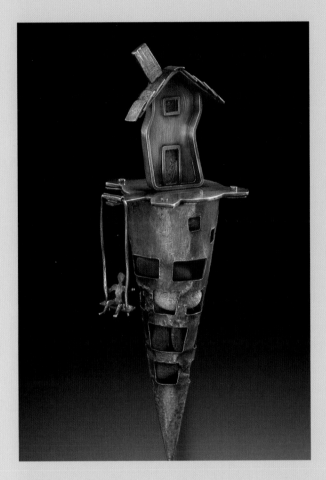

Assemblage artists working with new, shiny metal can age it in several ways—using rust or patina kits from craft or hardware stores, Dr. Ph. Martin's metal paints, or by oxidizing or aging it. A mini torch can be used to age and create beautiful patterns in copper or brass. Applying a solution of liver of sulfur is another method commonly used to darken metal and often used in assemblage jewelry like that by Greg and BJ Jordan.

Various techniques can be used to create beautiful patinas on copper and brass. Two recipes mentioned in *Metal Craft Discovery Workshop,* by Linda and Opie O'Brien, involve using salt and ammonia. A third, much-less-noxious approach, also mentioned by the O'Briens, is to fill a container with sawdust that has been dampened with white vinegar, dip clean and sanded pieces of metal in salty water, bury them in the sawdust, put a lid on the container, and wait.

TOOLS AND TECHNIQUES FOR CREATING ASSEMBLAGE ART

The tools and techniques necessary for creating assemblage art will vary with the kinds of objects you are combining, the substrate you are attaching them to, and the way in which you present them. In addition to the art supplies you already have on hand from collage work, you'll want to collect a few more. If you are creating a wooden shadow box for your assemblage, you'll need hammers, nails, saws, screws, screw drivers, drills, etc. In general, you'll want good woodworking tools and materials and possibly some power

Greg and BJ Jordan used a solution of liver of sulphur to darken the windows in *House on the Rocks,* a piece of assemblage jewelry.
Photo by Larry Sanders.

Robert Villamagna cutting into an old license plate with a pair of tin snips to begin an assemblage piece.

A large drill is an essential piece of equipment for an assemblage artist working with metal. Here, Robert is drilling a hole in the neck of what will be an assemblage doll in preparation for pop-riveting it to a globe body.

Robert using a pop rivet gun to make a cold connection and attach another doll part to the globe body.

equipment. You'll probably need wood filler and sandpaper as well. If you also use a found box or attach elements to a plywood base or to a large central assemblage piece, of course, you may not need as many tools.

How you attach elements to wood and to each other will depend on whether you are securing metal, plastic, glass, paper, fabric, or wood. For adhering fabric and paper you can use ordinary collage glues like acrylic gel medium or PVA glues. For bonding pieces of wood, Elmer's wood glue works well. Glass, metal, and plastic will need a stronger adhesive or an epoxy resin. Many assemblage artists have their favorite adhesives—Janet Hofaker uses E600 in her work, and Michael deMeng swears by Liquid Nails for attaching almost anything, rough or smooth. You can visit a local hardware store for advice on which glues to purchase to secure your chosen assemblage parts. Adhesives will list their capabilities on their containers. Just be sure to use adhesives that are strong enough to secure objects that will have others attached to them; this will add weight to the initial join.

If working with metal, you'll need drills, tin snips, shears, files, a pop rivet gun and rivets, pliers, hole punches, brass and copper nails, rubber and metal striking surfaces, rubber mallets, various hammers, wire, etc. If you are making cold connections, joining pieces of metal by making holes in them and attaching them via wire, screws, rivets, etc. without the aid of heat, you won't need a torch or soldering iron. But some assemblage artists find soldering irons and welding equipment useful tools and use both hot and cold connections in their art. If you have a wood shop or metal shop already set up you can just immerse yourself in assemblage art, but if you are just starting out, you will probably want to work on small projects at first and assemble special tools as the scale of your projects grow.

One of the best ways to get started in assemblage is to look
at other artists' works and learn how they went about creat-
ing them. Assemblage projects, large or small, are really jour-
neys in discovery, letting go enough for a work to lead you in
the right direction, and ultimately lessons in problem solving—finding
the right piece of memorabilia to coordinate with the others being used and the right way to
house or attach the elements to each other.

An old pinball machine from the 1950s (that was dam-
aged when the roof of a bar it was in fell through) and
the in/out office basket from the same period provided
the raw materials for this piece by Robert Villamagna,
entitled *Honeymoon*.

ASSEMBLAGE ART DOLLS

Mixed-media assemblage dolls can take any shape or form. Some are created from traditional doll-making materials and look similar to conventional children's toys, but contemporary art dolls may also have four, rather than two, arms and strange, sometimes evil-looking smiles. (If they, in fact, have a head to fashion it on!) Anything goes when entering this realm. Art dolls are often made from gourds, rusted metal, tin, bone, beads, feathers, and jewelry parts or, in the case of Susan Share, shoe laces.

THE METAMORPHOSIS OF MINERVA:
A MIXED-MEDIA ART DOLL BY OPIE O'BRIEN

Minerva's body was made from an intact vintage tobacco tin. Her head is also made from tin but is German in origin. Opie connected the head and body with wire and embellished the wire with vintage typewriter parts. Opie lives near lake Erie and sometimes finds assemblage parts brought in by the tides. Minerva's arms, in fact, were found on one of his beachcombing expeditions. They were wired to the sides of the tobacco tin and were decorated with more typewriter parts. For hands, Opie used vintage clickers from the 1940s. For legs, Opie used bowling pins, given as trophies to the bowlers with the highest scores. The names and scores can still be seen inscribed on the pins. Like the other appendages, the legs are attached by wire to the bottom of the tin.

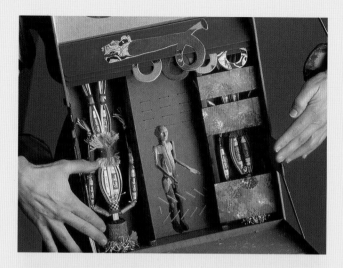

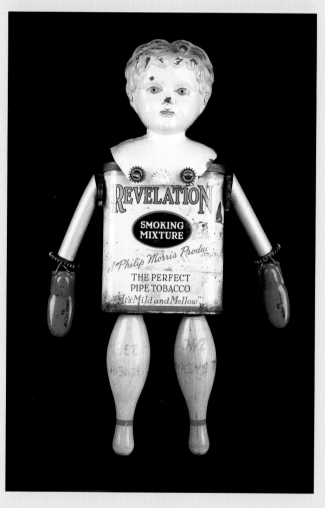

Top: Art dolls created from shoelaces populate a mixed-media box entitled *Carrots Anyone?*, created by Susan Joy Share and used in her performance art. Photograph by Clark James Mishler.

The Metamorphosis of Minerva, a mixed-media art doll created by Opie O'Brien. Minerva's arms were found on one of the artist's beachcombing expeditions. Photograph by Dina Rossi.

GABE CYR'S ART DOLL: *ALTERED ARTIST*

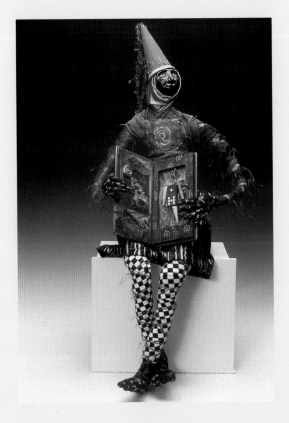

Gabe Cyr suspects that living with a seamstress grandmother and being surrounded by fabric trim and thread clippings probably laid the foundation for her art dolls. She notes that rather than attempting to "do art" she's more likely to play with a new combination of materials or a medium she's thought of a new way to use, and out of that comes the art. Gabe provided a very general description of how one goes about creating art dolls similar to the one shown. She stresses that one would need much more information and experience to create the actual doll.

"In general, to make a doll, the artist first has to create an armature of sculpture wire and then wrap it to shape with layer over layer of thick fabric strips. This fleshed form is then wrapped in at least three more layers of finishing fabric. Before the final layer, sewn and stuffed feet are affixed to the leg stubs. Sewn, stuffed, and armatured hands are attached to the arm stubs. A sculpted polymer clay face mask is affixed to the front of the head.

"What is done from that point is individual. The head is wrapped to cover the join of the face, and I add some sort of headgear. The final wrapping of finishing strips covers the body and joins of the hands and feet. In the case of the doll pictured, I made 'shorts' to go over the wrapped body. And as a final step, I made the altered book that the doll holds.

"I designed this doll form to be a holder/display stand for altered art. The doll is about 30 inches high, large enough to hold a book or other finished art in its hand."

A WEARABLE TIN CAN ART DOLL: *HOMEMAKER* BY LINDA O'BRIEN

Linda O'Brien's work "celebrates the forgotten and discarded items that more often than not seem to end up in society's ever-growing junk pile. One of my greatest enjoyments comes from breathing new life into these nostalgic castoffs," she says. "Since as long as I can remember I've loved odd dolls, unique jewelry, and

This assemblage art doll, *Altered Artist*, by Gabe Cyr was designed to be a display stand for the altered book she holds.

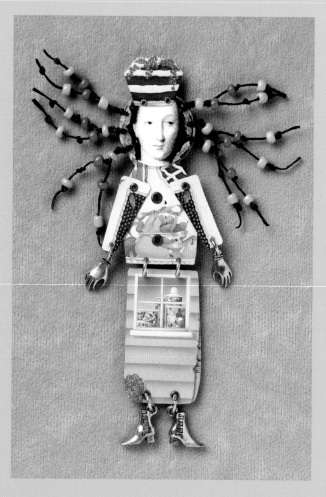

colorful tin cans (which, sadly, are an icon from my youth that are rapidly vanishing). "*Homemaker*," she notes, "is the end result of this particular obsession and the pairing of these elements."

The doll's body, hat, and arms were made from deconstructed lithograph cans. Linda riveted pin backs to the upper torso of the doll to make it wearable and also attached the upper arms to the torso with rivets. The face was scanned into her computer, resized, manipulated in her photo program, printed out, cut and laminated, trimmed, and riveted onto the tin can body, along with the hat. To create hair for the doll, Linda punched three holes into the tin on both sides of the head and added knotted and beaded waxed linen cord. She punched additional holes into the tin and eyeleted some (for embellishment) to allow the arms, hands, and feet to be attached with jump rings.

Note: Linda cautions that many of the "tin" cans available today are actually thin aluminum, which isn't good for such projects. Old vintage cans, cans coming from England and Germany, and many cans coming from third-world countries are still lithographed tin. Imported olive oil containers, she says, would be good tin cans for an aspiring assemblage artist to start working with. And a word of caution: you may want to wear protective gloves when working with tin. Cut edges can be very sharp!

ASSEMBLAGE JEWELRY

Screws, nails, buttons, keys, coils, springs, gauges, bottle caps, coins, computer parts, and bicycle chains are but a few of the societal castoffs that are embraced by artists creating assemblage jewelry. Rings, pendants, bib necklaces, and bracelets contain unusual found objects and shades of patina that are a colorful and textural feast for the eyes.

Homemaker, a wearable tin can art doll, by Linda O'Brien.
"Homemaker's" hat, arms, and body were cut from colorful lithographed tin cans, which sadly are becoming a rarity today.
Photograph by Dina Rossi.

SUSAN LENART KAZMER'S TALISMAN JEWELRY

Jewelry designer and assemblage artist Susan Lenart Kazmer describes the way in which her materials speak to her and influence her assemblage jewelry. "I have always had a passion for found objects. Recently I have considered another dimension utilizing found objects. Picking up a piece, holding it, and contemplating it, I let the object lead the way as to what direction the finished piece will emerge. The magnitude of energy carried with found objects from their previous lives can be seen, felt, and touched. When you close your eyes and hold the object in your hand you can feel whether the user had enjoyed, neglected, or cherished it. Fear, happiness, struggle, and strength are also feelings embedded in an object. My job as an artist is to take the found object and present it in a new and unexpected way.

"Combining these energies in recycled objects is indeed creating a contemporary talisman. Consider the mental power put into a pencil stub worn down by an accountant during tax season, or the mundane repetition locked into a key from an old factory locker, or the freedom embedded in the bones of a free-range chicken. I believe these energies lend power and mystery to ordinary objects. In my work I use them to create talismans worn for protection, freedom, and strength

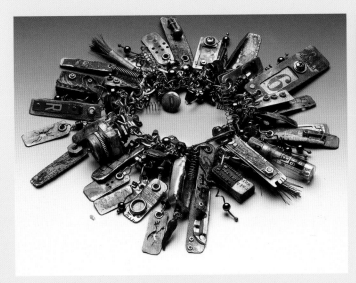

Altered Surfaces, an assemblage bracelet by Susan Lenart Kazmer. Susan uses various methods to age and add patina to the trinkets, charms, and found objects she uses in her art.

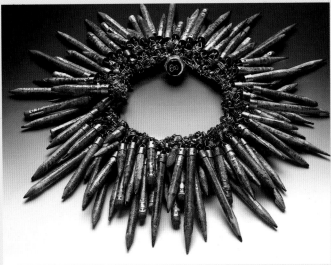

The Energy Talisman, a piece of assemblage jewelry that artist Susan Lenart Kazmer created to imbue its wearer with "protection, freedom, and strength."

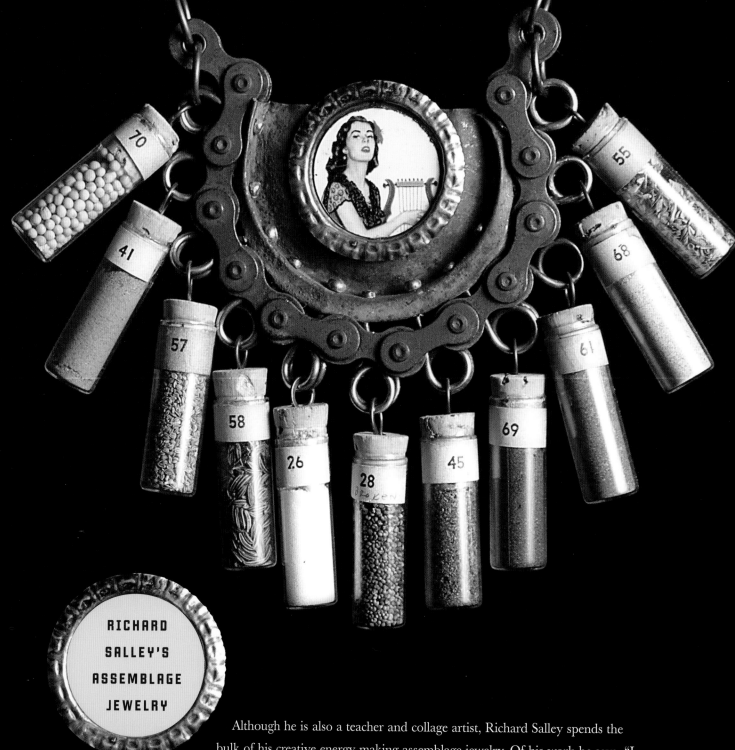

Although he is also a teacher and collage artist, Richard Salley spends the bulk of his creative energy making assemblage jewelry. Of his work he says, "I particularly enjoy working with found objects and with somewhat unconventional and nonprecious materials not often found in jewelry. I find it very rewarding to take things that are considered useless, like a crushed tin can or rusty washer and combine it with lowly iron or copper wire and turn it into a piece of art."

Glass vials holding various spices dangle from a vintage bicycle chain in the tongue-in-cheek work *Spice of Life*, an assemblage necklace by Richard Salley.

Richard shares how he created an assemblage pendant in the following photos and text.

The project begins with a rusty steel automotive flange, a bronze one-dollar U.S. coin with the image of Sacagawea, an obsidian arrowhead, and various gauges of iron wire.

A laser-printed sun symbol is applied to the copper disc using an acetone transfer technique. It will be etched for thirty minutes and be given a liver of sulphur patina.

Making jump rings using a 16-gauge iron wire and wrapping it around a wooden dowel.

Sawing the jump rings.

A cage of 16-gauge wire will hold the bronze coin in place.

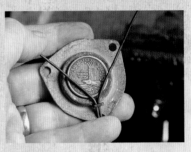

The coin is put in place, and the wire cage is bent into a preliminary position.

The back begins to take shape.

The loose ends are curled to form an anchoring mechanism for holding the cage in place along the top of the flange.

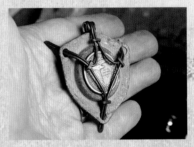

The coin is ready to be secured in place.

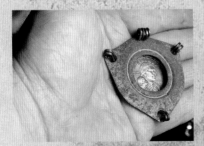

From the front you can see how the wire has been curled over, which snugs up the wire on the back of the piece and holds the coin tightly in place.

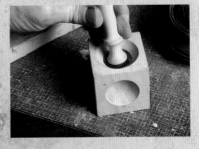

A wooden dapping block is used to give the disc a domed shape.

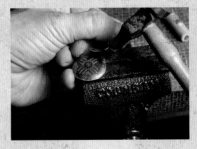

The wires are attached to the shaped and etched copper disc with 16-gauge wire rivets. (A wire staple holds them in place for this operation.)

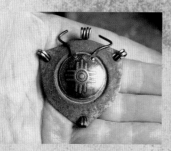

The hinge wires are cut to length and bent into shape.

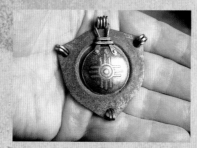

The hinge has been pushed into position and held by two flattened wire straps.

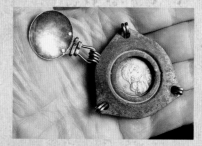

The domed lid has been flipped back to reveal the coin inside.

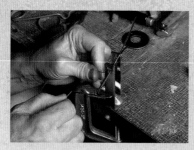

A wire winding jig is used to create 21-gauge iron wire coils.

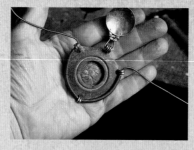

Two lengths of the coiled wire are put into place around the outside of the flange. They are slipped over a piece of 16-gauge wire.

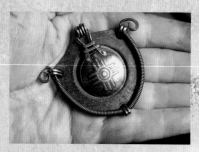

The wire has been cut, curled, and hammered flat.

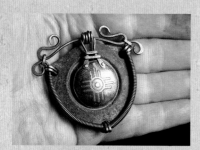

Another decorative and functional wire is added, to be used for attaching the neck cord.

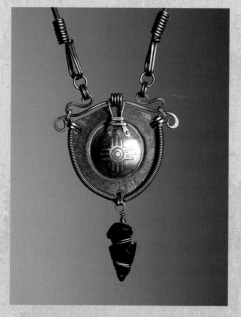

The final touches include adding a few jump rings, attaching the arrowhead and the neck cord, and then polishing everything.

ASSEMBLAGE SHRINES

Assemblage artists creating shrines are not necessarily interested in making a religious statement and constructing a place to house their religious artifacts. The shrines being made by assemblage artists today are more likely to hold objects of personal significance that might make a political or humorous statement or house a collection of things reminiscent of childhood or a family's history. A shrine enclosure can be constructed, or an object like a hollowed-out gourd or a sardine can be chosen as a depository and filled with assemblage elements to tell the artist's story or deliver his or her statement.

Carol Owen creates her shrines from ³/₁₆-inch foam board and paper, which she paints and decorates with collage techniques and embellishment. Paper ephemera fills the niches of her "spirit houses," which she often creates for others, using bits of memorabilia they provide, like buttons and keys, game pieces, baby blocks, costume jewelry, bits of antique lace, and commemorative spoons. Carol then adds stamped images of numbers and letters. She also uses bones, shells, and bits of nature like tumbleweed and twigs, which often appear as fence posts or pillars in her shrines. To give the shrine an aura of mystery, Carol photocopies images and text on transparencies and layers them over other paper memorabilia like maps and photographs.

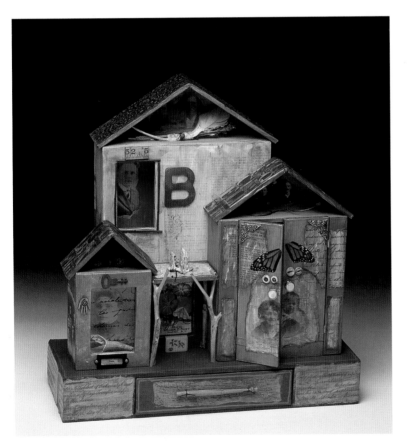

Dream, an assemblage shrine or "spirit house" created by Carol Owen. Paper ephemera, found objects, and bits of nature fill the niches of the house, which is populated by vintage photos of those who've passed on.
Photograph by Seth Tice-Lewis.

Top: Michael deMeng uses lenses, gears, and photos to transform lowly sardine cans into assemblage shrines like *Sardine Can Nicho*.

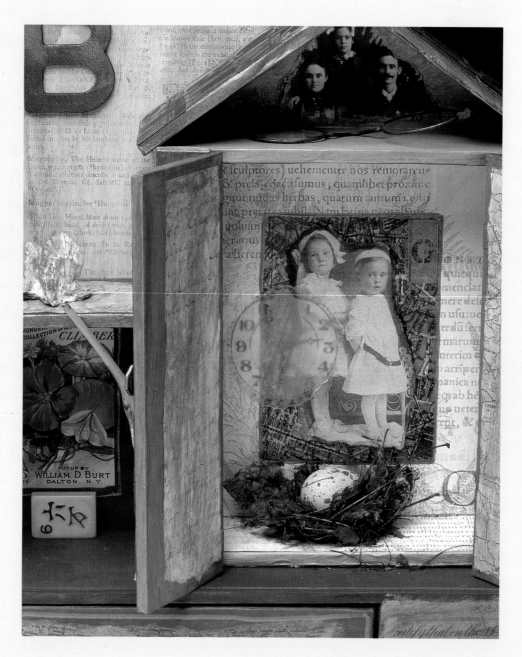

To unify the collage elements and add to the sense of mystery the spirit house emits, she often goes over the collage elements with a light wash of acrylic paint. Like most assemblage artists Carol lets her medium lead her. In her book *Crafting Personal Shrines*, she says that she tries to avoid "the danger of having a preconceived idea of what the shrine should look like and trying to impose that idea on it instead of letting it become what it wants to be. The work is always better and richer," she says, "if I follow where it wants to lead me."

A detail shot of *Dream*.

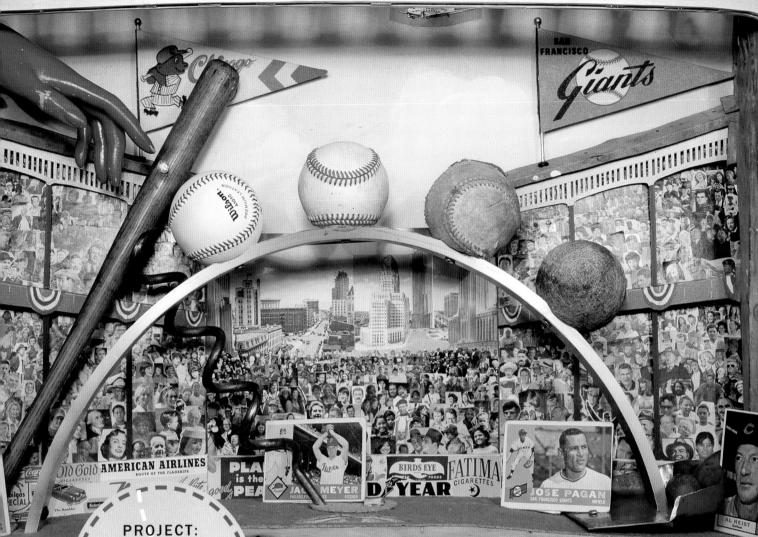

PROJECT: AN ASSEMBLAGE IN A SHADOWBOX

LIFE CYCLE OF THE COMMON BASEBALL BY JEFF MATHISON

Jeff Mathison has written a kind of journal of the way in which he approached and constructed one of his assemblages.

The Life Cycle of the Common Baseball began with a walk, not a home run. The local ball field is just outside of the village we live in. It was early spring, and the brush surrounding the field had been beaten down by the winter snow. I spotted one lost baseball after another and brought home a bag full. I was struck by their progression from barely used to only a hard core remaining. A line of baseballs sat on my bookshelf for some time, and I came to think of it as a baseball's version of progress through life. I added a red hand from an old department store mannequin to the lineup to give a Sistine Chapel–like start to the cycle.

Sketch plan for *Life Cycle of the Common Baseball*.

A trial fit of the found objects, after the basic box was built.

The bleachers were built of scrap plywood.

Hundreds of small spectators were collaged into the bleachers.

A scrap of copper flashing became the bleacher roof.

When I decided to make a fully developed assemblage, the next step was to round up a few other items I already had that fit with the idea, such as the miniature bat. With a general concept forming in my mind, I drew up a scaled plan. Then I went to my shop and built the basic pine and plywood box. A trial fit using a foam core arc to hold the balls confirmed the concept would work.

The project really got rolling with construction of the thin plywood bleachers and billboards. I was looking for an overall effect that would suggest a museum diorama rather than being some exact scale copy of a stadium. So I flattened the perspective of the bleachers and supports for the billboards. I created a sky with pale summery clouds in acrylic paint. On the same paper, I painted the upper level railings with flag fans. To populate the seats, I cut out hundreds of pictures of people, mostly from old *Life* magazines, and collaged them to paper, smaller faces to the rear to create perspective. I cut and pasted the crowd collage into the stadium seats and added the billboards, railings, strips of matboard for pillars, and the patinated copper roofs, cut from scraps of copper flashing found in a pile of old house debris.

To soften the top edge of the assemblage's background, I added a piece of pine, carved to create a gentle transition into the sky. I spread Elmer's wood glue evenly over the plywood back of the box and carefully adhered the cutout sky.

I rounded the copper destined to become the assemblage sidewalls by bending it over a scrap of sewer pipe. Again, I liked the idea of evading right-angle sides by curving the copper to suggest old stadium pillars. I temporarily placed the completed bleachers in the box to show me where I needed to cut and bend the copper around them.

The placement and attachment of the old mannequin hand was a critical issue I had to solve. About the same time I was working on

the copper, I also bent some scrap aluminum into the arc that would support the balls as the foam core arc had done in the mock-up. When I had a pretty close idea of how the major elements would fit, I marked and cut the hole for the hand in the copper. I puzzled over how to securely attach the hand. Fortunately, the hand had some built-in hardware that I was able to attach to a home-made plate. I finally firmly secured the hand to the sidewall of the box with several screws that ran through the plate.

To suggest a small city behind the bleachers, I collaged a couple of postcards from an antique store and old *Life* magazine advertise-ments. With that glued down, I could finally install the sidewalls with copper nails to avoid galvanic corrosion. I then fastened the bleachers with small screws that I covered over with more cutout faces.

The field itself was the next area to construct. I knew I wanted the pitcher's mound to be higher than the rest of the field. I found an old piece of pine with a nice aged look to the edge, which I was able to chisel and plane to the shape I needed.

As I trimmed the aluminum arc to fit to its final length, and attached the four balls, I realized the arc was top-heavy. To solve the problem, I added an additional small horizontal aluminum brace that connected the large arc to the back of the box. I drilled through the field to make slots for the arc and devised hardware to secure it.

Meanwhile, I did some shopping, both on eBay and in a local antiques mall, to come up with the pennants, baseball cards, and the child's dustpan. The felt pennants are glued to the tips of old car aerials and also secured by triangular boxes of matboard I con-structed, to keep them stiff. When I came across the dustpan, I knew it was a perfect symbol for the end of the life cycle, even

The hand-painted sky was glued to the plywood back of the box.

The completed bleacher was inserted into holes in the copper side panel.

The mannequin hand required handmade hardware to secure it to the wood.

Old postcards provided a city backdrop for the stadium.

The main arc was attached with rivets to a supporting brace.

The Giants pennant rests on a triangular box of matboard for support.

A cardboard template helped locate the hole where the arc passed through the dustpan.

A cutaway provides a glimpse into the underworld passage of the baseball.

matching the color of the hand. Unfortunately, I did have to cut part of it to fit it within the box and cut a hole in it as well to allow the arc to pass through it. To avoid making an error in the actual placement of the hole in the dustpan, I cut a cardboard template of the dustpan and marked exactly where the aluminum arc would pass through it.

I felt the cycle of life needed some suggestion of what might happen on the flip side of the concept, so I gouged a small hole into the base of the box and installed a scene of a pearl-sized ball traveling the underworld on another arc of weathered copper wire.

Providing grass for the baseball field proved to be a puzzle for some time. I tried several kinds of paper and cloth before deconstructing an old corkboard. The back of the cork was fibrous, providing the perfect fine texture. I gave it a green watercolor wash and was very pleased with its late summery, dry appearance.

Another element that proved difficult was the spandrel that overhangs the front of the box. It's meant to suggest that the viewer is looking at the field from inside another section of the stadium. A first attempt, cut out of plywood, was too flat and too ragged. I finally resorted to cutting thin slats of wood and constructing it in 3-D. After painting it, I aged it by allowing some gray and brown spray paint to fall on it from a distance and by rubbing gray dirt into the crevices. Screws angling in from the top attach it to the sides of the box.

A coil, suggesting a screwball pitch, was cut from a dog's tie-out stake and added to the interior of the box. The coil's end was placed in a hole I drilled at an angle in the ball field and then secured with a nail. I attached the bat by using a large screw that came in from the back of the assemblage and into the heavy part of

the bat and a small screw that passed through the handle of the bat into the ball field. I mounted a glass gem, suggesting the spark of life, on a part from an old technical pen, which I set into a hole in the bat.

The broken base of a wineglass served to cover the view of the underworld. I cut out a circle of grass for the pitcher's mound and flipped it over to the cork side. I used bits of broken china plates for the pitching rubber and home plate and propped up the baseball cards with matboard easels.

With the inside done, I tried several possibilities for the top billboard, settling on the curved-top design. A brass plate from a printer's tray gave me the old museum look I wanted for the explanatory text at the base of the box. On the back of the box, I mounted a swinging half-circle plate. Underneath it, I placed my signature. After dressing it up with some bits of molding, I gave the outside of the assemblage box four coats of acrylic paint. I painted flag fans on some heavy watercolor paper to decorate the box sides. To reward viewers who linger and look closely to really appreciate my work, I added a couple of barely noticeable surprises: two pigeons in the spandrel and a small plane flying over the field.

A FEW GENERAL NOTES

There's a big sand trap in the Game of Art—the tendency to bog down in too many possibilities of material, technique, and composition. Once I had done a reasonable amount of thinking and planning, I found it important to just start nailing things in and worry about making the next element fit in later. It was also important to have a lot of materials and hardware at hand. Nothing wrecks the pace of a big project like having to run to the store for every little thing you need. My pack rat tendencies served me especially well, as many of the odd items I used could not be bought anyway.

The backside of corkboard was painted green and glued down to simulate grass.

A handmade spandrel graces the top of the box.

A crystal, mounted on a part from a technical pen, represents the spark of life.

The completed interior of *Life Cycle of the Common Baseball*.

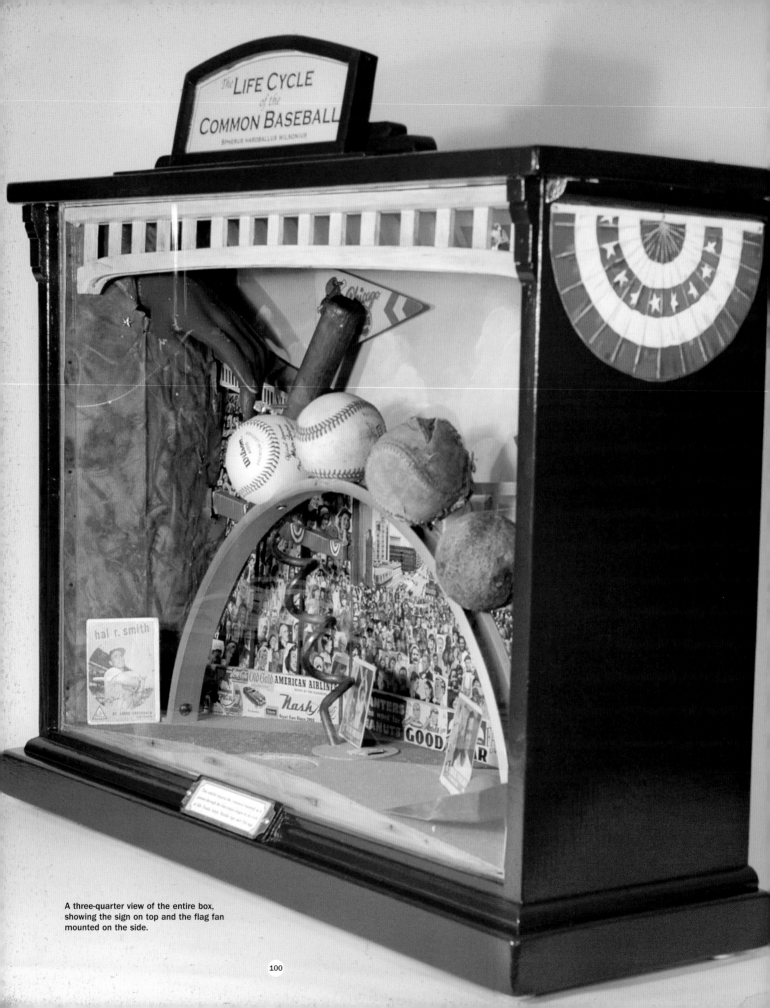

The LIFE CYCLE
of the
COMMON BASEBALL

hal r. smith

A three-quarter view of the entire box,
showing the sign on top and the flag fan
mounted on the side.

GALLERY

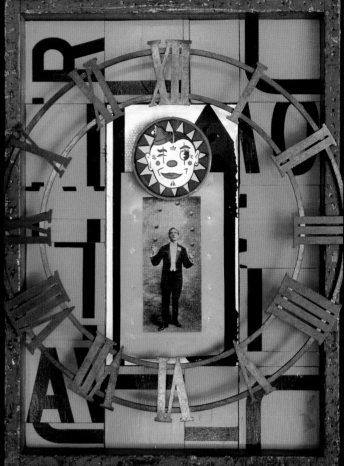

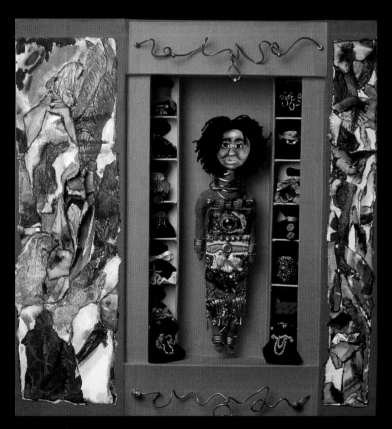

The Juggler by Robert Villamagna. Robert scanned and transferred an image from a 1920s magic book to a metal plate to create the juggler in this work. The vintage brass clock face is a comment on the way we, too, manipulate time and juggle our priorities.

The green crone, honoring the female writer, is an assemblage doll, one of seven figures in Martina Johnson-Allen's large fold-out mixed-media structure entitled *The Seven Crones*. The figure is made entirely of fabric and embellished with appliqué, painted surfaces, wire, beads, findings, and twigs.

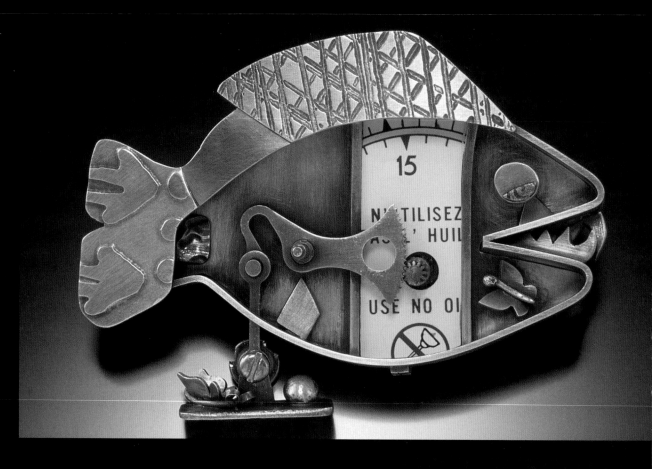

Fish Scales, an assemblage brooch by Greg Jordan containing sterling silver, brass, 14k gold, and found objects.
Photograph by Larry Sanders.

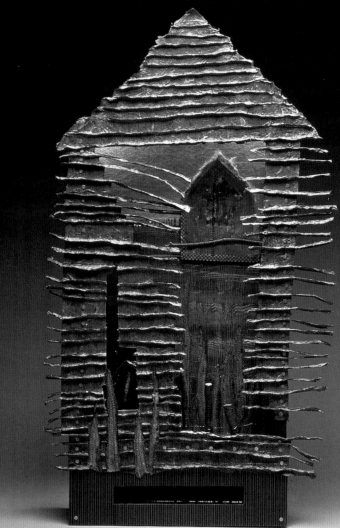

Things We Leave Behind, an assemblage by Jennifer Lee Morrow. Handmade and commercial papers, wood, copper, waxed linen, nails, thread, paint, and mirror were used to create the work.
Photograph by Ken Woisard.

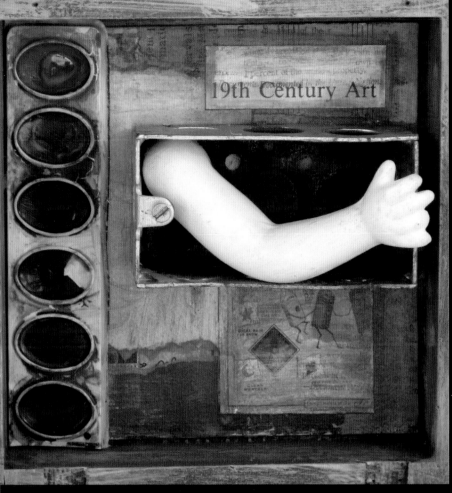

19th Century Art, an assemblage box by Janet Hofacker. Janet has aged and distressed the box and its paper ephemera contents through grattage, dry brush, and color wash techniques.

F.J. Wagner! 50 by Leo Monahan. This assemblage box was created as a birthday gift for a German journalist friend of Leo's.

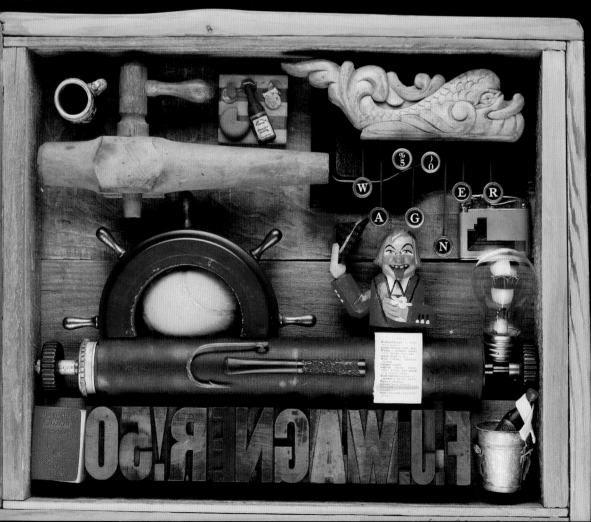

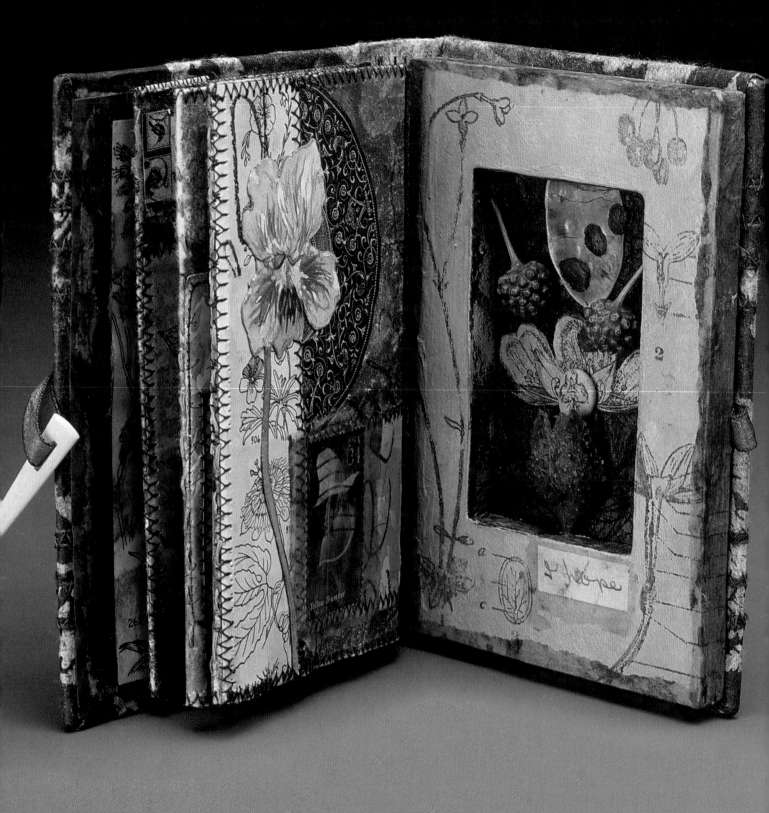

See My Meaning, a mixed-media altered vintage book by Sharon McCartney. Sharon's book features a deep niche holding her signature natural found object inclusions, stitched accordion-fold pages, and attached signatures. Photograph by John Polak.

ALTERED ART

Altered art is the transformation of an ordinary object into a piece of artwork. The name is a bit confusing, but most people understand the term if they think of it as altered *object* art. The object can be anything, large or small—a hat, birdcage, cigar box, or Pez dispenser. As with assemblage and collage, the near relatives of the altered art movement, vintage objects are generally considered more interesting to work with than contemporary ones. Altering objects is not a new phenomenon; eleventh-century monks routinely scraped ink off vellum manuscripts dating as far back as the fourth century to create a blank slate on which to pen their own words and illustrations. Such altering is known as *palimpsest*, from a Greek word meaning "scraped again." Paintings, too, have been altered for centuries. Art restorers are often amazed to find an even older painting emerge from below the one they are attempting to clean.

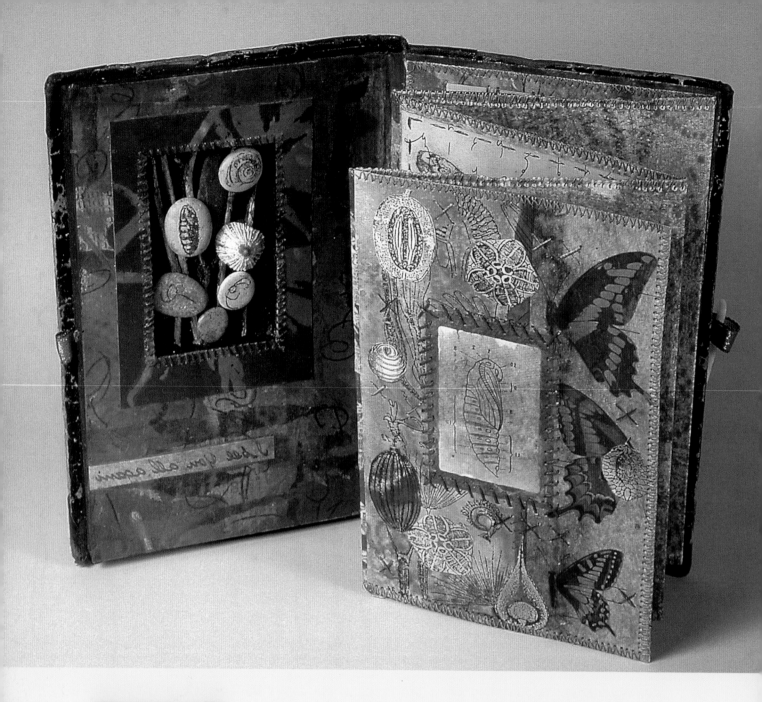

Books, of course are the most commonly altered objects. Altered books have been at the forefront of the altered art movement for several years, and the question is no longer if it's all right to cannibalize a book but rather how to get your hands on an interesting title to alter. Most altered-book artists do prowl the book sales with a bit of a conscience, however; they look for books that are old and dog-eared and check to make sure they aren't about to carve up a first edition.

A partially opened view of *I See You All Again*, a mixed-media altered vintage book by Sharon McCartney. Photograph by Marcia Ciro

British artist Tom Phillips is recognized as the father of the altered book movement. In the 1960s he bought an old Victorian novel for three pence and turned it into what he called a "treated" book. He spent decades altering it, obliterating lines and pages to create a new story, and adding new illustrations and paintings. The altered work was published in 1983 and titled *A Humument: A Treated Victorian Novel*. *New York* magazine dubbed it "the closest a paperback book has come to being an art object."

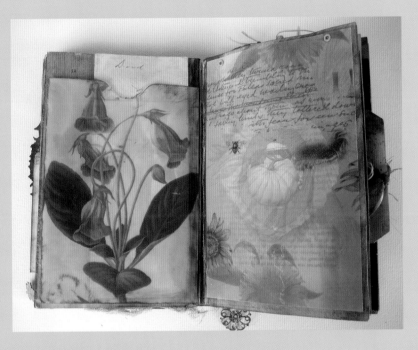

GETTING STARTED

Used hardbound books can usually be found at thrift shops, garage sales, and, of course, used bookstores. Libraries also often have excess titles or damaged books for sale for a nominal fee. If the cover is marred or a few pages are ripped or marked up with ink, it won't matter. You can alter the cover and either discard the pages or accept the challenge of working the flaws into your design. Just be sure that the book is not so old and fragile that pages fall out or are brittle enough that they'll crack and split after you've invested time on them.

TRADITIONAL ALTERED BOOKS

If you plan to alter your book in the traditional way, by decorating pages and adding memorabilia, you'll need to remove some of the pages to accommodate the extra paper you'll be pasting into the book. Some altered-book artists remove every fifth page. Others, planning to include more dimensional ephemera, remove even more. To remove a page, place a cutting mat beneath the page you wish to remove and, using an X-Acto knife, cut out the page as close to the spine as possible.

The next step for basic bookwork is to create a block of pages on which to start decorating or making a collage. Unless you're altering a child's board book, you'll find that pages are too thin to really support much collage work. By gluing several pages together, you'll create a better support on which to start tinting, masking text, or gluing things down. A dry adhesive like a glue stick or adhesive film will be easiest to use

Translucent vellum gives a sense of romance and mystery to the pages it partially obscures in this altered book by Carol Owen.

and will be least likely to wrinkle pages. If you do decide to use a more liquid glue, be sure to slip sheet the pages around the page block with waxed paper and press the book overnight. (Note: Because book pages are so thin, sometimes they wrinkle from coating them with paint to tint them. If you coat pages with a paint like Lumiere rather than one with a high water content, your book pages will be less likely to wrinkle.)

ALTERING COVERS AND PAGES

The same techniques used to create collage art can be used to decorate altered books. Some altered books, in fact, use collage on almost every page. Painting, stenciling, stamping, stitching, batiking, weaving, using transfer techniques, aging and tinting paper, printmaking, folding, and pleating can be done on book pages or on paper to be collaged onto the pages.

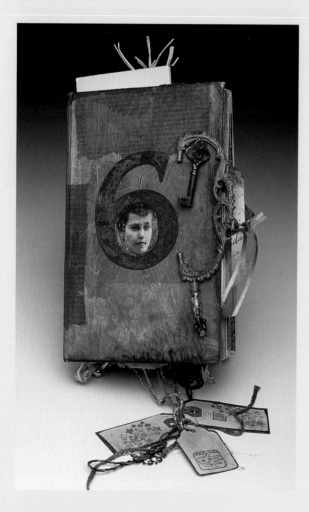

The collaged cover of *Six*, a mixed-media altered book by Carol Owen.
Photograph by Jerry Anthony.

Additional features like masked text created by applying removable tape over words you wish to preserve and painting the page around them), folded pages, page slits, windows, shadow boxes, pockets, and pop-up pages can be added to altered books, which makes them even more interesting in texture and dimension. With pages to turn that lead to surprises, niches full of memorabilia to explore, and windows to open, lift, and peek behind, altered books are the epitome of interactive art; engaging and fun to explore and create.

DECORATING BOOK COVERS

Although some altered-book artists like to like to minimize cover decoration and let the surprises begin inside the book, many find the cover an ideal place to collage with three-dimensional objects. After all, few altered books are designed to be slipped beside other books on the bookshelf. The heavy board, which makes up a book

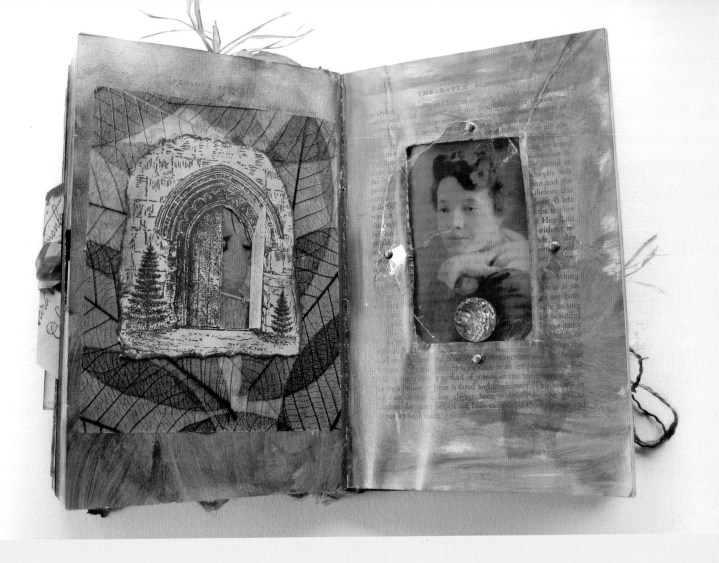

cover, is, of course, the ideal backing for collage work. Papers can be layered on top of each other and extended around the spine of the book onto the back cover to continue the work.

CREATING WINDOWS AND DOORS

With the aid of an X-Acto knife, square, and cutting mat you can cut a rectangular or square window or door in a page or thin block of pages. The opening can highlight a picture, text, or flat object like a coin or feather that shows through from the page below. Pieces of mica, transparent film, or screen can be placed over a picture placed beneath the window or sandwiched between pages before they are adhered together. Circular windows can be cut with large hole punches or with circle cutters like those made by Fiskars. (Be sure to practice cutting circles on scrap paper first, as some cutters take a bit of getting used to.) Doors and windows that open and close can also be cut in papers to be collaged onto a book page. Stamped images of doorways and windows or photos of doorways you may have taken can be cut and folded back to reveal an image collaged onto the paper below.

An arched door is partially adhered to a decorative paper on a page in Carol Owens' *Six*. The door opens and closes to reveal and then obscure a perching cardinal.

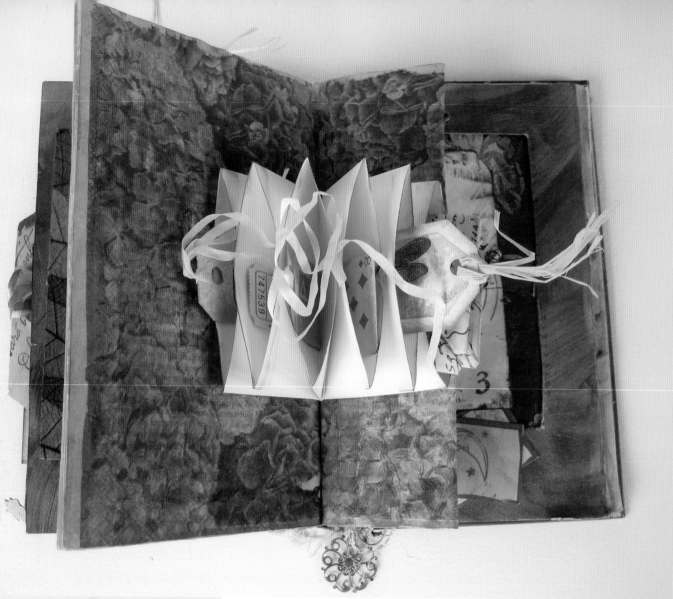

A series of manila envelopes, adhered together at the base and to adjoining book pages, hold paper ephemera like tags, tickets, and cards in Carol's book.

A series of folds on adjoining pages in *Six* creates pockets to hold paper treasures. The top fold was created by slitting the page partway down to facilitate folding it into a V shape.

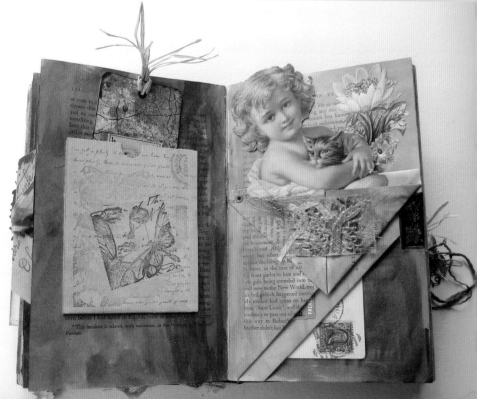

CREATING SLITS AND ENVELOPE POCKETS

Horizontal or vertical slits can also be cut in book pages to accommodate tags and cards or to allow flat memorabilia to be inserted in them. To allow for room to insert the memorabilia, be sure to glue the page with the slit to the page below it by applying adhesive only around the *edges* of the two pages to be joined. Small envelopes, either purchased or created with origami techniques, can also be glued onto a page to hold surprises within. Glassine envelopes or envelopes made from translucent vellum are fun to use because they allow the partially veiled contents of the envelopes to show through. A series of coin envelopes partially adhered to each other and to adjoining pages offers another way to insert tags or memorabilia that invite viewers to peruse the hidden treasures.

Applying a strip of dry adhesive to a folded book page.

When adjoining pages have been folded and coated with a strip of adhesive, they can be adhered in position on the pages below to create four pockets for paper surprises.

FOLDING PAGES

Folding individual pages back on themselves and adhering their edges is also a good way to create a pocket to hold flat ephemera or add a dimensional element to the book. Single pockets can be created or several pages can be folded under, creating several places to add ephemera. Page folding can also provide a decorative element, as successive pages with wider folds peek out from the previous ones. By creating symmetrical folds on adjoining pages and partially adhering the folded pages to pages beneath, four pockets can be easily formed. Just take the upper and lower outside corners of a single book page and fold them toward the spine of the book, making sure that their edges meet, as shown. Then flatten the folds to give the page a point. Apply glue or run a strip of double-sided tape along the seam between the folded edges and press the folded page in place on the page below it. If you repeat these directions on the adjoining page and adhere it in place on the page below, you will have created four pockets on the page spread.

To really explore the possibilities of page folding, try folding more shallow or more extreme angles, and don't worry about being symmetrical or creating a point at the edge of the page.

CREATING POP-UPS

Surprise cutouts that pop up as a viewer turns the page can really enliven an altered book. A simple pop-up step, like that shown, is easy to make. Just fold one of your book pages in half and, using a square, X-Acto knife, and cutting mat, make two parallel slits partway down the page, as shown at right. The slits should be even in length and about an inch and a half apart. Fold and crease the flap of paper along an invisible line that connects the base of each slit. Then open the page, reverse the fold, so the mountain fold is now a valley fold, and push the little step through to the back of the page. Adhere a simple cutout, stamp, or other flat, lightweight surprise to the step to finish.

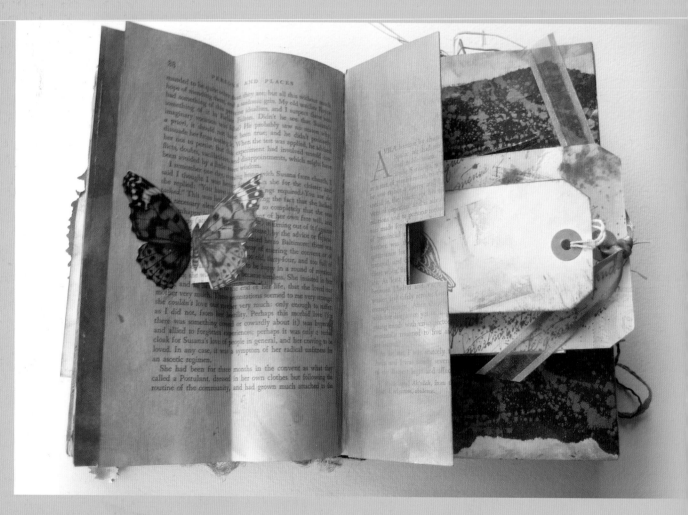

The pop-up step in Carol's book supports a butterfly. The adjoining green page also contains a step that has been pushed through to the other side. It will pop up when the page is unfolded.

Top: Folding and creasing the base of the parallel slits that form the pop-up step. When the step is pushed through, it will resemble the green page in the photo above.

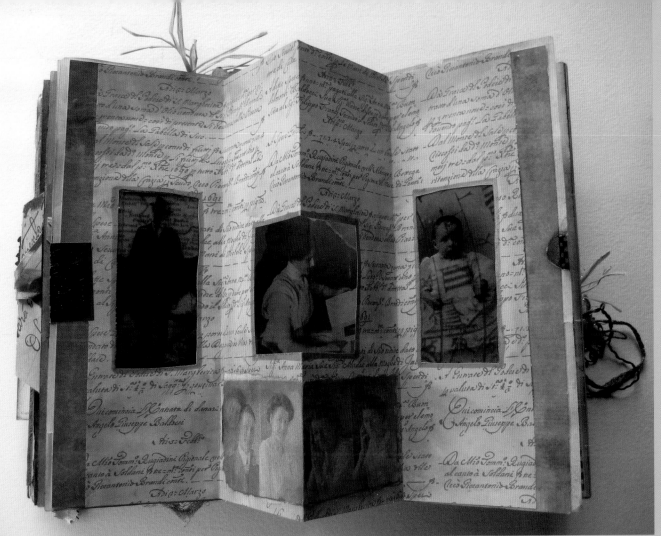

A windowed pop-up that reveals a picture pasted below it can be made by gluing an accordion-folded sheet of paper over the pages of your book. The paper can be an inch or so wider than your open book and about the same height. Begin by folding the paper in half and then folding each half again. Reverse the folds as necessary to give you four equal accordion folds. Cut a window in the center fold large enough to reveal a photo (also folded) placed in the gutter of the book. Position the pop-up page so that it opens with a tented shape and closes correctly, tucked back inside the book covers, and adhere the sides of the page to the pages below.

The interior of the pop-up shows that a photo and paper on which it rests were both folded and glued into the gutter of the book.

Top: The accordion-folded pop-up that spans two pages of Carol's book.

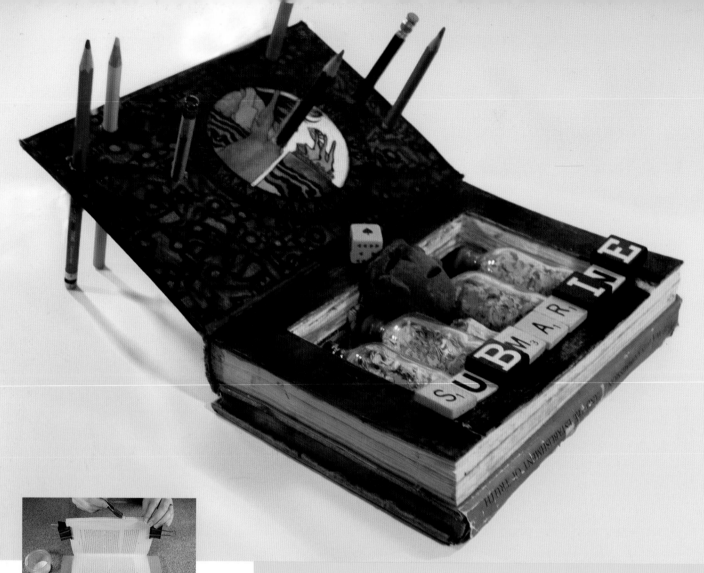

Applying gel medium to the edges of a page block to stabilize the pages and begin transforming them into a shadowbox. Screws at all four corners of a stack of pages could also be used to immobilize the pages in preparation for cutting a deep niche.

Cutting into the page block to begin hollowing out the book to create a shadowbox.

CREATING SHADOWBOXES

Cutting recessed openings in your book will allow you to add three-dimensional elements like shells, bones, game pieces, buttons, seed pods, and other embellishments that add character to your book or help carry a theme. Depending on the size of the object or objects you wish to showcase, your opening can be a shallow niche or can be more like a shadowbox, an opening that extends through the entire stack of pages that make up the book. To create a stable shadowbox, it's best to use a book cover as the base of your box.

Begin by gathering a number of pages together, starting with the endpaper or page adjacent to the book cover. The thickness of this block will determine how deep your opening will be. Place waxed

Submarine by Tomas Cassidy contains a shadowbox that extends through all the pages of his book. To comment on his passion for book hunting and collecting, Thomas filled small bottles with brittle bits of pages salvaged from old distressed editions of Verne, Twain, and Eliot. Photograph by Fucci.

paper over the adjacent pages to keep them clean, hold the pages together, and, using a flat brush, apply an adhesive like gel medium to all three edges of the page block. Clamp the pages together as you work, and keep the pages clamped together until the gel medium dries.

When the glued pages have thoroughly dried, use a pencil and square to draw the size and shape of the shadowbox on the top page. You can also trace around a postcard or the interior of a picture mat. If you line up the top of the card with the book type, it will sit squarely on the page. Then, place a cutting mat under the page block and using a metal-edged ruler and a very sharp X-Acto or mat knife, begin cutting along the penciled lines to begin hollowing out the book. Remove a few pages at a time until you have tunneled all the way through.

Next, apply glue or gel medium to the back of the hollowed-out page block and close the book. Apply pressure along the edges of the back cover to seat the block firmly against the back cover. Weight the book until dry.

When the book is dry, reinsert waxed paper to protect any adjoining pages and begin painting the edges and surface of the page block, the bottom of the shadowbox or niche, and the inside edges of the block to coordinate with the adjoining page. Then glue in the objects you wish to showcase in the book's opening.

ALTERING BOARD BOOKS

Children's board books containing extra-thick chipboard pages are ideal for artists looking for a short altered-book project. The books are inexpensive, easily found in thrift shops, and usually contain only a few pages. Because the pages are thick, you needn't worry about pages warping from being wet with glue or paint. They are often cut into interesting shapes, like houses or hands, which also makes them fun to work with. The only downside is that the pages are often too slick to accept paint.

To prepare the books for altering, sand each page horizontally and vertically with medium-grit sandpaper. Wipe the pages clean and then paint each page with two light coats of gesso, which will obliterate any pictures and give you a clear surface to work on. This will take some time, as pages should not contact each other until the gesso is absolutely dry. When the gesso is dry, you can begin painting or collaging the books.

Janet Hofacker, whose *A Reconstructed Book* is pictured on page 116, shared some of the techniques she used to create it. After gessoing the board pages, she used Yes! Glue to collage sewing pattern tissue onto them. She angled the tissue, layering sheets over each other.

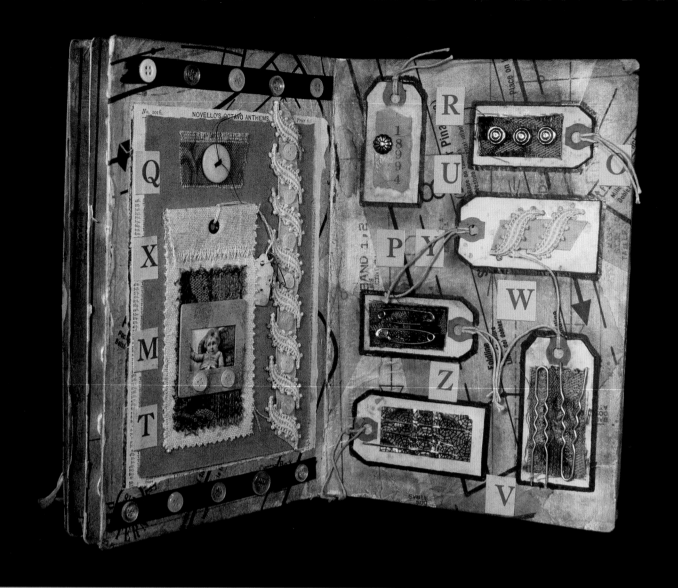

Instead of working directly on the tissue-covered pages, Janet tore some manila folders to the correct size to use as background papers. She assembled and glued photographs (reproduced in sepia tones on her computer), vintage sewing notions, old book pages, sheet music, fabric, lace, tags, decorative trim, etc. onto the manila folders. This allowed her to use her sewing machine to machine stitch around the outside edges of the ephemera to continue the sewing theme of her book. She set eyelets on some of the pages to do some hand sewing as well. Then, using Yes! Glue, Janet adhered the manila-backed collages to the board book pages and pressed them overnight.

When the pages were dry, Janet rubbed brown chalk over the edges of the pages to antique them. Janet gave her book the finishing touches by adding rubber stamped quotes and numbers and letters and using E6000 glue to affix objects like game pieces, metal snaps, buttons, and safety pins.

After gessoing the pages of her altered work *A Reconstructed Book*, Janet Hofacker collaged sewing pattern tissue onto them to use as a background for the sewing notions, photos, tags, and buttons she added.

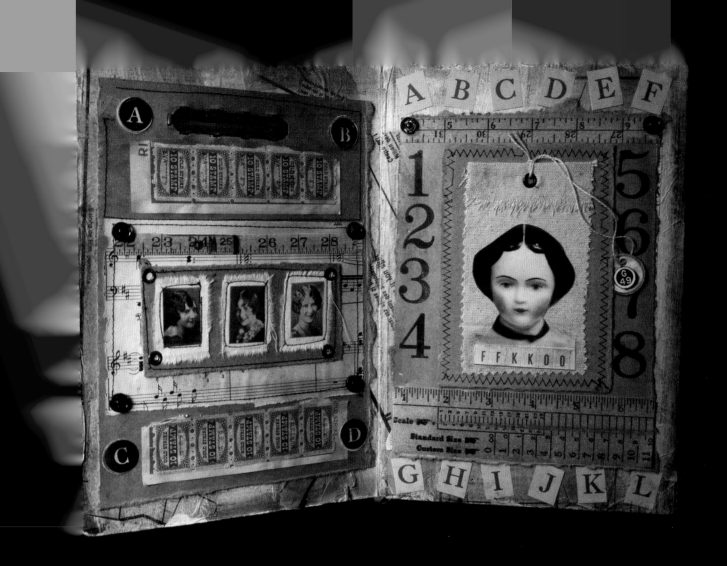

Janet artfully tore some manila folders as background papers and, before gluing them to the board book pages, machine stitched around the ephemera to continue the sewing theme of her book.

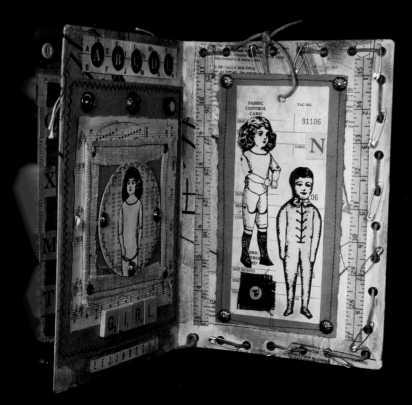

After the collaged manila folders that were glued in place had dried, Janet rubbed brown chalk over the board pages so that all parts of the book were unified in sepia tones.

NONTRADITIONAL ALTERED BOOKS

Some of the most striking altered books I've seen are departures from the traditional altered book genre. The nontraditional-altered-book artists rely on folding, cutting, tearing, and hollowing-out pages to make a statement instead of using paints, stamps, and colorful collaged ephemera. In many cases the book is transformed into a piece of sculpture.

PAGE FOLDING AND MANIPULATION

Instead of folding just a few pages to make pockets, some altered-book artists create books that are made entirely of folded pages. The repeated folding increases the page volume so much that it forces the book to stand open, giving the book a sculptural presence. The ink from the text or book illustrations appears on the edges of the folded pages and, like the repetitive folding, creates visual interest. Page folding can be done on books that retain their covers, or covers can be sliced off so that the page folds create a sculpture in the round. Pages can simply be folded in half lengthwise or assume numerous other configurations to create interesting freestanding structures. Consistency is key here, however. If one page is folded incorrectly, it will ruin the effect.

Mary Bennett, whose altered art is shown here, is well known for her stunning books, which are shown in galleries and museums. She describes her approach to creating her works: "I do not make books but alter already published volumes. All get folded, sewn, shredded, punctured, or any combination of the above. As someone who was raised to have a great deal of respect and reverence for the written word, it might

A collection of altered books created by Mary Bennett. Consistent, repetitive page folding forces the book open and gives it a sculptural form.

seem strange that I can mutilate or rearrange what had originally started to serve another purpose. My interest is in making something new and wonderful from an object that has outlived its usefulness. All books I work with have been rescued from the landfill."

Mary manipulated the pages in the book shown in the photo below to give them a rippled appearance, which increases their volume and creates a sculptural form. To create the "ruffled" books, Mary tries to use books with very thin pages that are already aged. She rolls each page individually around a No. 2 pencil. Then she carefully pulls the pencil out and wrinkles the page. She rolls five pages in one direction and then five in the reverse, so the bend is always upright and doesn't slant one way or another. She unrolls each page after wrinkling and smoothes it with her hand. Then she moves on to the next page. Mary jokes that she listens to a lot of bad television while doing one of these because she can't watch and must pay attention to the rolls. She once ruffled a three-thousand-page German-French dictionary that turned out looking like a ruff from Victorian times. "The best books for this type of thing are Bibles and missals," she notes, "because they have lovely gilt on the page ends."

Mary Bennett rolled and wrinkled each page to create
this altered book.

NONTRADITIONAL NICHES

Various types and depths of niches can be cut in books by "drawing" into successive pages with an X-Acto knife, by repeatedly removing parts of a page with a circle cutter, or by artfully tearing parts of the page away. All are time-consuming, tedious jobs, but if done carefully, they pay off with a striking altered book. Julie Leonard, whose works are in many permanent collections, likes to work with old reference and botany books. She meticulously cuts pages that move progressively deeper into the book. She often begins the cut by following the outline of a beautiful illustration on the page. She then cuts the next page in the same shape, but just a bit smaller, and so on through the book. Then, taking some of the pieces removed, Julie collages them back in, to create a layered, cascading look.

The niche in Mary Howe's *A Book Louse's Feast* was made by carefully tearing away successive pages in a very aged book to make them look like they were devoured by book lice that crawled over it. Mary created a printing plate by carving an image of a book louse in a Soft-Kut printing block, inked it, and then block-printed and cut out multiple images to attach to her book. The lice are each little altered books, too, filled with the mixed-up letters they ate.

Tara O'Brien's books feature niches that are hollowed out with circle cutters. Her *A Treasury of Science*, which houses a working clock, is a comment on the way scientific theories and definitions change with time. Her altered book *Kernel* contains a niche made of cut concentric circles. A clear Plexiglas ball magnifies words as it rolls over them.

Julie Leonard followed the outline of an illustration on a page and cut progressively deeper into the body of the book to create *Layering Time*. She then collaged back in some of the pieces that were removed.

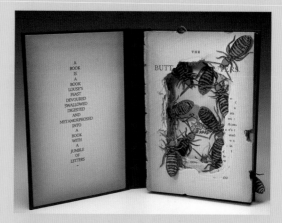

A Book Louse's Feast by Mary Howe. The niche in Mary's vintage book was carefully torn, page by page, to make it look as though it had been chewed apart by the block-printed insects that decorate it. (See also page 140.) Photograph by Ken Woisard.

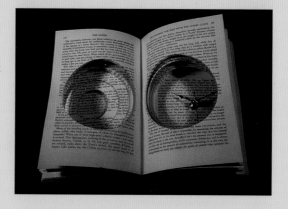

The cut pages in *A Treasury of Science* by Tara O'Brien were created with a circle cutter. The book houses a working clock.

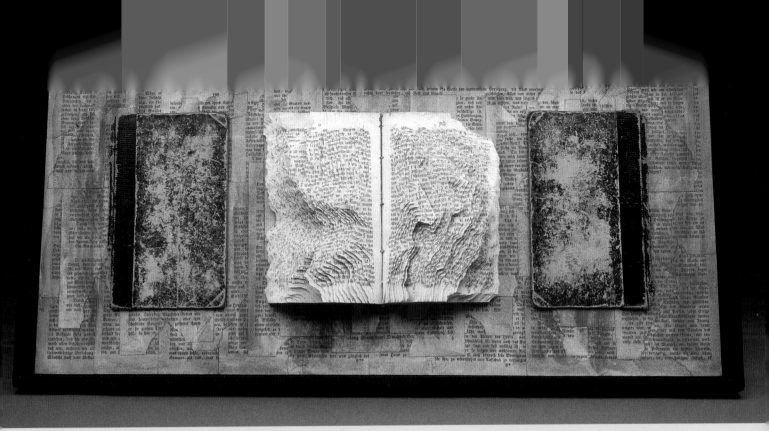

TEARING AND CUTTING PAGES AND COVERS TO CREATE SCULPTURAL FORMS

In addition to hollowing out the interior of a book, some altered-book artists like Julie Leonard severely cut or tear pages, artfully deconstructing the book so that the interior of the book takes on the appearance of rocklike ledges and natural terrain. She tries to maintain the lines of type to give the altered books a sense that they might still be read. In much of her work, Julie "uses words and the book, its physical form and textural content, as image, in order to weave a meaning that can be sensed, rather than be literally understood."

Other altered-book artists totally remove pages and reassemble them as parts of other structures. Daniel Essig's book sculptures utilize rag text paper from Bibles and dictionaries from the 1800s. He uses books that have mangled spines or covers; books that are not rare and have "lived out their lives" but still contain good quality paper. Antique Bibles lend themselves especially well to Daniel's work because they have very thin paper that drapes and flows, as in his *Niche Bridge Book*, pictured above.

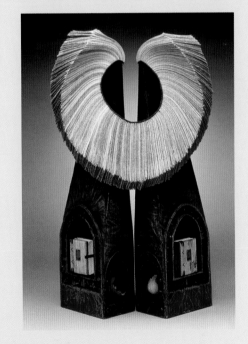

Top: By severely tearing the pages of her altered book *Shrouded Passage* so that each page is slightly wider than the previous one, Julie Leonard transformed the pages into paper ledges that evoke the feeling of natural terrain.

Above: *Niche Bridge Book* by Daniel Essig. Daniel often uses thin text paper from vintage Bibles and dictionaries because the paper drapes well, as shown in the altered book sculpture pictured. (See also page 1.)

Pamela Paulsrud's *Book Stones* are carved with "power tools and perseverance" from whole books. I first came across her work in a gallery setting, where her books were presented intermingled with many smooth stones. They so perfectly blended in with the natural elements that initially I didn't see them. When I finally did recognize them, I was amazed at how well the text, barely visible on the edges of the sculpted books, mimicked the natural striations on the edges of stones. She describes her inspiration, the technical process used to create the tiny altered books, and the creative problem solving she had to engage in before she was able to bring her concept of merging stones and books to life.

"My art is about process, content, and resonance. The books are selected for color, structure, content, and age. They are cut using various angles on a band saw. The book parts are sanded on a rotary sander with coarse, medium, and fine sandpaper, then finished with hand sanding using extra-fine sandpaper and lots of tactile inspection and caressing. If the spine is too loose, I often glue it with PVA.

"But, it is the formation and discovery of each 'stone' that continues to fascinate me. The process of 'making art' includes so much more than a step-by-step guide, which really can't be discounted. The entire process creates resonance and discourse. Walking on the beach, picking up stones, meditating, having dreams about them, finding the stories within the stones, and discovering their correlation to books (an age-old one perhaps, yet finding that discovery within one's self is quite a different understanding)—each step is part of the process.

"Initially, I might add that the process included several failed attempts at achieving the concept. First, spending countless hours with a hand saw cutting a foot-and-a-half-wide piece of alabaster in an attempt to carve a book out of stone. (I now use the term 'cutting the stone' to refer to the struggle in the process.) Secondly, fusing a book and stone, which worked visually but was too large and lacked the tactile and resonant quality I was seeking. The cut books, however, led to the small bookstones when I saw the pattern created from the text, similar to the strata in a stone. The books began to resemble the stones I'd been collecting all along."

Top: By viewing Pamela Paulsrud's *Touchstones* on display among the stones they are meant to resemble, one can see how well the barely visible text that shows on the edges of the tiny altered volumes mimics the striations of natural stones. (See also page 141.)

Bottom: A close-up of Pamela's books with the books slightly open reveals the fact that they actually were conventional books at one time and that text that still fills them.

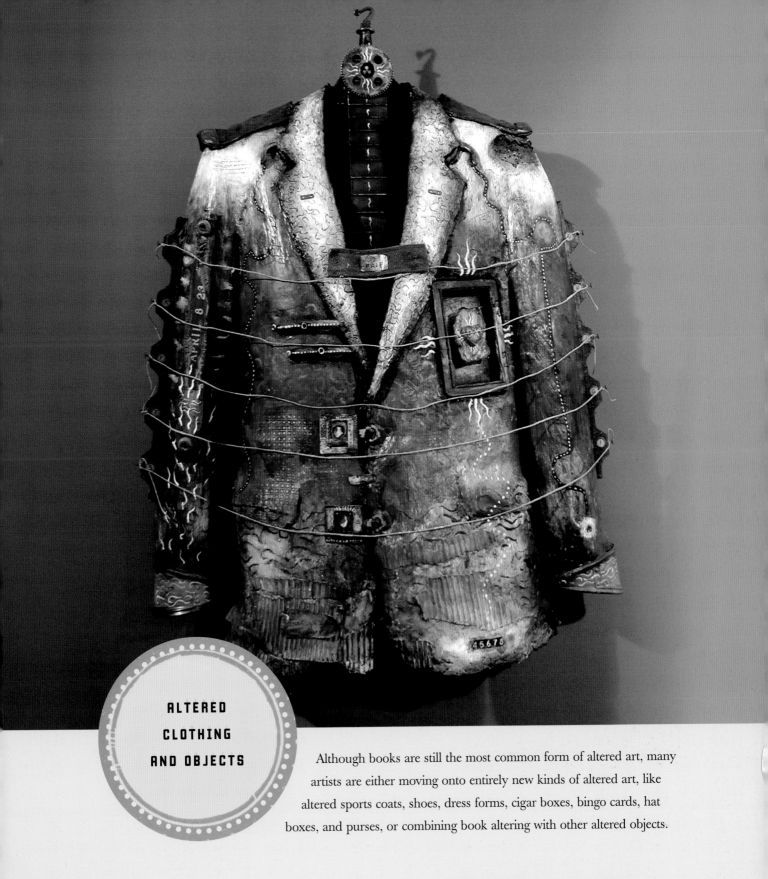

ALTERED CLOTHING AND OBJECTS

Although books are still the most common form of altered art, many artists are either moving onto entirely new kinds of altered art, like altered sports coats, shoes, dress forms, cigar boxes, bingo cards, hat boxes, and purses, or combining book altering with other altered objects.

Hot by Michael deMeng, is part of a series of altered jackets that are hardened with plaster and resin and then painted and outfitted with various "doo-dads."

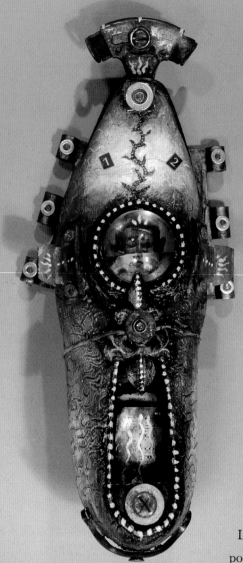

ALTERED CLOTHING AND ACCESSORIES

Michael deMeng's altered work *Zen Shoedism* began with a woman's shoe, which he hardened with plaster and acrylic paint. It was outfitted with a lens over an eerie photo of an unsavory-looking fellow. Then it was filled and embellished with hinge parts, screws, washers, and other rusted and faux-rusted assemblage elements, or "doo-dads," as Michael calls them. (This piece of altered art could just as well have gone in the Assemblage Shrines section of this book. Michael was, in fact, inspired to create the work because he felt that shoe shapes, like irons, possess the perfect shrine shape.) Like many of his amazing assemblages, the piece grew on its own as he constructed it and in the end was quite different from what he had originally planned.

The altered coat, *Hot*, on page 123, is one in a series of altered coats done by Michael, which are partially encased in plaster and partially in resin. Cocooning the coat in plaster not only hardens it into a permanent shape but makes it possible to write on it. The concept for the coat series was inspired by the illness of a family member. Although she recovered, the experience started Michael thinking about the body as the shell or coating of the soul. The altered clothing that Michael created in response to the illness addresses issues of mortality and fragility.

Larry Thomas scours yard sales and flea markets for small purses and pocketbooks to use in his altered art. Discarding the bag part, he uses the hardware to make new "pocket books." The collaged pages of the unconventional books feature creatures, at first innocent-looking enough, but upon closer inspection, oddly "different" and clearly up to no good. Book artist and curator Carol Barton sums up the interior of the altered pocketbook and many of Thomas's other works when she says, "Thomas's books are like the court jesters of old. The antics on their pages are nimbly entertaining, but they belie some serious issues: ethical behavior, prejudice, misplaced social values, violence, and war. Thomas coaxes his viewers to question their positions on these subjects through a humor that is both humane and constructive."

Michael deMeng chose a woman's shoe for his altered art *Zen Shoedism* because he was enamored of the shrine-like shape. It was hardened and then filled with various assemblage elements.

Opposite Bottom: *I Used to Be Snow White, but I Drifted* by Lisa Austin. Lisa transformed a yard sale find to create her altered hatbox. Embroidery and beading embellish the photo-transferred image of Mae West.

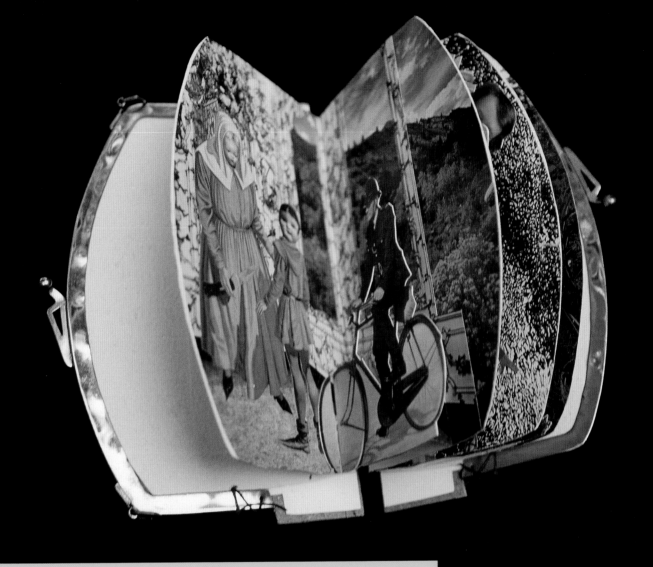

Lisa Austin's altered vintage hatbox, *I Used to Be Snow White but I Drifted,* started with a rather plain-looking garage sale find. She embellished the outside of the box with vintage ostrich feathers and leopard fur from an old collar and then transformed the interior. The inside of the hatbox features a ribbon-wrapped embroidery hoop that holds a piece of fabric bearing a photo-transferred image of the actress Mae West. Lisa embroidered and beaded the fabric and added a junk jewelry clip to give the Hollywood "bad girl" the kind of adornment to which she was accustomed.

Top: *Pocket Book # 5*, one in a series of pocket books by Larry Thomas that is a combination altered book and altered purse. The pictures that fill it appear mundane until you take a closer look.

ALTERED COMPACTS

Sharon McCartney often combines pages from vintage books, found objects, photocopy transfers, stitching, vintage papers, teabags, dried mushrooms, and butterfly wings and then houses them in vintage objects. Her work "explores the connections between ornament and organic regeneration" as she "shelters remnants and relics, minutiae, and symbols in antique books and vintage compacts." In their closed positions, the altered compacts give barely a hint of what's inside. Once opened, the machine-stitched flap pages fold out to reveal a wealth of drawn, painted, and collaged treasures waiting to delight and enchant the viewer.

Top: The art that appears on the cover of the altered compact *Moonlight and Music* by Sharon McCartney barely hints at the wonders that appear inside.
Photograph by John Polak.

Once opened, Sharon's altered compact *Moonlight and Music* reveals fold-out pages filled with collages of vintage papers, teabags, stamps, gelatin prints, photocopy transfers, stitching, and other art media.
Photograph by John Polak.

ALTERED NEEDLEWORK AND VINTAGE TEXTILES

Sharon McCarthy creates beautiful altered art using lace, handkerchiefs, doilies, and other vintage fabrics. She describes her art: "My recent work with vintage textiles and paper explores the art of collecting and celebrates past ages when utilitarian objects were beautifully finished with extra details such as delicate stitching or well-formed script. I like the resonances of these objects, the evidence of their histories, the effects of aging on their surfaces. Ephemera, old handwriting, fragments of aged textiles, and engravings from old botany books appeal to my need to rediscover and layer aspects of these eras to my own drawings and paintings. As I incorporate these elements into my work, I often alter the filter of their exact content, yet I invite the character of the materials to remain. I try to find connections between antique ornament, weathered surfaces, and the cycles of organic regeneration."

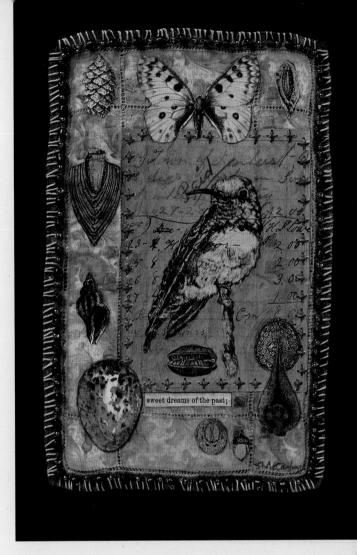

ALTERED UKULELES

A love for the Hawaiian Islands led Peter and Donna Thomas, well known for their miniature books, to embrace the ukulele and use it in book making. The ukele's main body is sometimes replaced with a book,

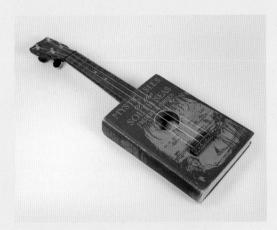

as in *Ukulele Series Book #8, Mystic Isles of the South Seas*. To create it, Peter and Donna attached the neck of a ukulele through the top end of a copy of the book. A sound hole was drilled through the cover, revealing some of the text, and a bridge was mounted on the cover below the sound hole. The book opens at the back cover, so the title page was moved to the back of the book so it could still be read. To create another work, the Thomases sawed a ukulele in thirds to create a "bentwood shaker box," pictured on page 142.

Ukulele Book Series Book #8, Mystic Isles of the South Seas by Peter and Donna Thomas. A love of the book arts and of Hawaii inspired Peter and Donna to create altered works that combine books and parts of musical instruments from the Islands.

Top: *Sweet Dreams of the Past* by Sharon McCartney. Vintage linen forms the basis for this altered textile, which includes hand stitching, beads, photo transfers, and parts of vintage letters and book pages.
Photograph by John Polak.

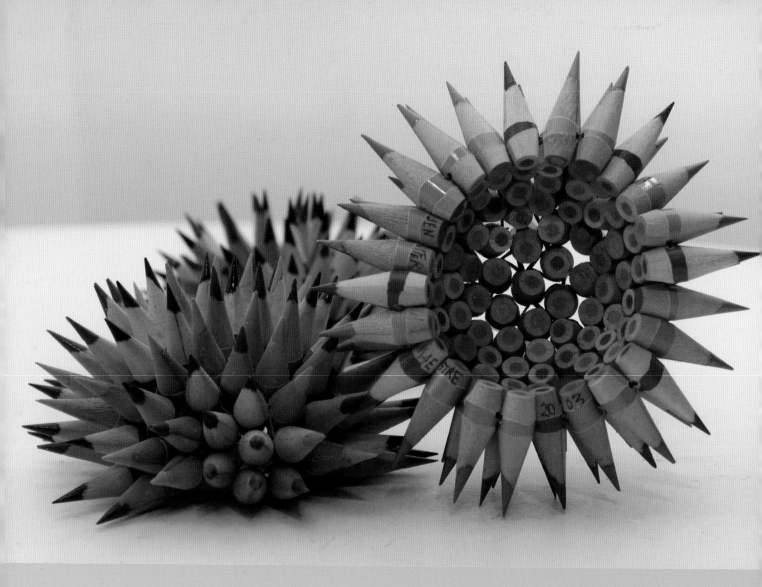

ALTERED PENCILS AND NAILS

Jennifer Maestre alters and combines groups of common objects, like pencils and nails, in such a way as to create altered art that both invites a viewer to touch and warns them to stay away. Her sculptures were originally inspired by the form and function of the sea urchin whose spines "so dangerous yet beautiful serve as an explicit warning against contact. Their fierce exterior protects a precious and vulnerable interior. In much the same way," Jennifer notes, "our outer self can convey an emotional state at odds with our interior one." This visual metaphor, she explains, is at the root of her work.

Jennifer created *Dawning*, the nail sculpture, pictured opposite, by pushing nails through window screen using liquid rubber as glue so the pieces would remain flexible. Then, using her sewing machine, she sewed a functional zipper into part of the screen. The nail-studded egg shape on the interior of the sculpture is an actual

Sea urchin pencil sculptures by Jennifer Maestre. The inverted urchin shows the peyote stitching Jennifer uses to join the hundreds of 1-inch pencil stubs that make up her altered pencil work.
Photograph by John Puleo.

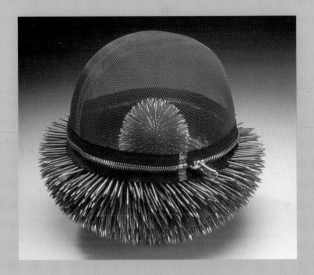

eggshell with nails attached. To create it, Jennifer blew the interior out of an egg, coated the empty shell with liquid rubber, painted it with nail polish to disguise its natural color, and glued the nails on with liquid rubber.

To make the pencils sculptures, Jennifer took hundreds of pencils, cut them into 1-inch sections, drilled a hole in each section (to turn them into beads), sharpened them all, and sewed them together with a peyote stitch beading technique.

Jennifer's journey from the conception of her idea for a sea urchin sculpture to its final realization in her pencils sculptures is fascinating and shows how creative problem solving coupled with exposure to new materials and techniques can lead an artist to the final exciting *Ah-ha!* moment. She explains: "I started off in the direction of prickly things when I was in my last year at Massachusetts College of Art. It all comes from

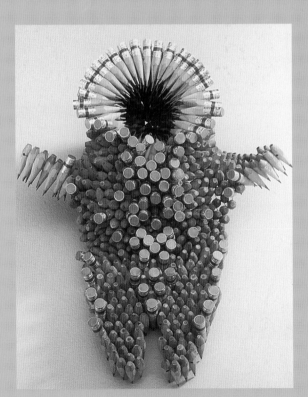

one idea I had for a box with a secret compartment that would contain a pearl. The box would be shaped like a sea urchin, made of silver. In order to open the box and reveal the secret compartment, you'd have to pull on one of the urchin's spines. The idea was of something beautiful, sculptural, but that you wouldn't necessarily want to touch, and that also held a secret treasure. I never developed the small-metals skills to ever make the box, but it got me thinking about that kind of form. I started experimenting with different materials to make urchin forms. I found that nails pushed through window screen worked well, and I could use many different types and textures and colors of nails.

"After graduation, I kept playing with the nails and screen (very low tech) and gradually started working

Voodoo Muse, an altered pencil work by Jennifer Maestre.

Top: *Dawning*, a nail sculpture by Jennifer Maestre. Nails, an egg, a zipper, and mesh were used to create this piece of altered art.
Photograph by Dean Powell.

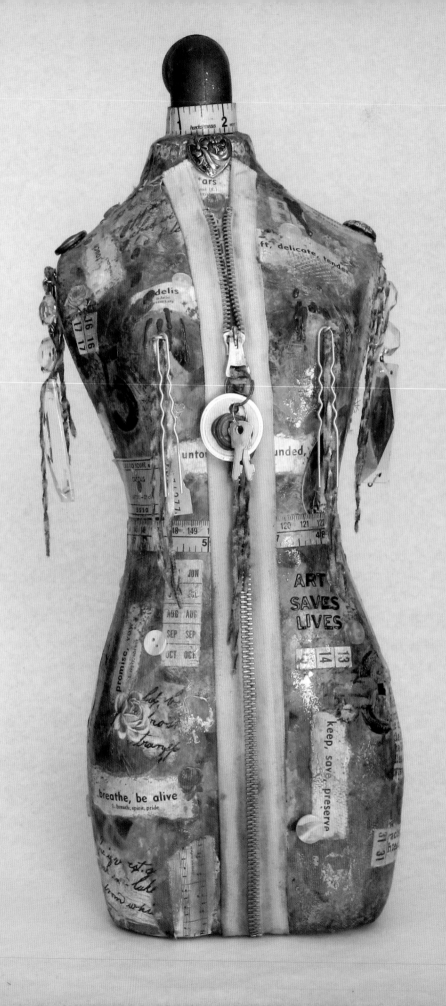

larger, adding zippers and other elements. Continuing with the container theme, I started making tack-coated eggs to place inside the nail baskets. The eggs were so beautiful on their own, as well, that I decided to open some of them up, putting little windows in, for example. While I was doing that work, I was also dabbling in beadwork. I taught myself several beading techniques, especially peyote stitch, which is great for creating sculptural work.

"I was constrained a bit with the nails, because I couldn't get all the turns and twists I wanted. I loved the textures and the contrast between the industrial qualities of the nails and the organic forms of the sculptures, but I wanted more complex forms. I was also thinking about how bad for my health the liquid rubber probably was. So, I experimented with other pointy things and techniques and finally hit on turning pencils into beads and sewing them together. Using this combination of technique and materials allows me to retain all the qualities that I want in my work, with the potential for more variety of form."

ALTERED DRESS FORM

Papier maché dress forms are popular three-dimensional objects being used by collage artists to create altered art. Janet Hofacker, who has created a number of "decorated torsos," as she calls them, shared some of her techniques for altering them. Janet usually begins by creating text to collage onto the dress form, using rubber stamps and permanent ink or by making copies of old handwriting or text found in books. Parchment paper has a good vintage look that she likes, but Janet notes that thin tissue paper molds more easily to the curved surfaces of the dress form. Next, Janet tears the paper into small pieces and, using acrylic medium, applies them randomly to the torso. She sometimes applies lace at this point using gel medium.

Then she chooses a basic color scheme for the torso and mixes up three shades of paint, diluting each with a small amount of water to use as a dye for the papers she has collaged onto the torso. Janet uses a sea sponge to dab on one of the shades of the diluted paint and wipes off any excess with a clean cloth. Then she sponges on the remaining two shades of paint to create the illusion of dimension.

After the paint is dry, Janet may apply foil or gold leaf to the surface of the dress form. Then she'll add jewelry, buttons, finials, or other assemblage objects with a strong jewelry adhesive and hang earrings, tassels, or crystals from the shoulders of the dress form with tiny screw eyes. Janet often paints or gilds junk jewelry or a belt buckle and applies it to the form to finish altering it.

Art Saves Lives, a decorated torso by Janet Hofacker. Janet often begins one of her altered works by collaging text, created with rubber stamps and copies of paper ephemera, onto a dress form with acrylic medium. Photograph by David Hofacker.

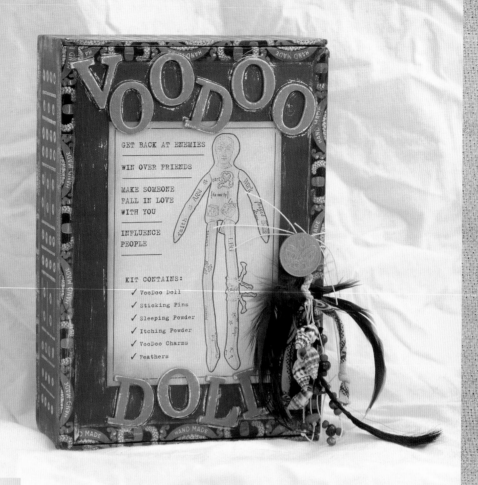

GET BACK AT ENEMIES

WIN OVER FRIENDS

MAKE SOMEONE
FALL IN LOVE
WITH YOU

INFLUENCE
PEOPLE

KIT CONTAINS:
✓ VooDoo Doll
✓ Sticking Pins
✓ Sleeping Powder
✓ Itching Powder
✓ VooDoo Charms
✓ Feathers

PROJECT: ALTERED CIGAR BOX AND MUSLIN DOLL: THE VOODOO DOLL KIT

Many people have used cigar boxes as a great starting point in making altered art, collaging them or outfitting them with handles and turning them into purses. Michelle Bernard-Harmazinski went several steps further and transformed an ordinary cigar box and muslin doll into a Voodoo Doll Kit, especially for this book. She provided the photos and complete instructions, with specifics on exactly what coloring agents she used to create the Voodoo Doll Kit shown here.

The exterior of the voodoo box.
Photograph by Debra Tlach.

Doll Materials List:

- 14-inch bendable muslin doll
- Adirondack Color Wash sprays: espresso and butterscotch
- Archival ink: jet black
- Disposable latex gloves

- Embossing heat tool
- Liquid Stitch fabric glue
- Muslin scraps, unbleached
- Non-Stick Craft Sheet or scrap paper
- Plastic baggie

- Rubber stamps: alphabet sets, words, sayings, and images
- Scissors
- White sewing thread

CREATING THE VOODOO DOLL

Working over a sink and wearing disposable gloves, lightly mist a muslin doll with espresso Color Wash Spray. Mist from the center out, leaving the extremities—head, arms, legs—only half-covered. Turn the doll over and color the back in the same manner. Use butterscotch Color Wash Spray to mist the head, arms, and leg areas left uncolored in the previous step. Color the back, sides, and any other uncovered areas of the doll.

Using your gloved hand and water, moisten the doll to blend and lighten the dyes until the color looks aged, worn, and faded. Squeeze out the excess dye and water. (Repeat the previous directions on an 8 x 8 inch piece of scrap muslin. You'll be using this later on.) When the desired look is achieved, dry the doll and the scrap piece of muslin with an embossing heat tool. You may also let it air dry overnight on a protected surface.

Stamp the doll with "voodoo-type" images and words. You can use alphabet stamp sets to make your own words or use rubber stamped words or parts of sayings to decorate your doll. Create visual interest by using stamps with different type styles.

Misting a muslin doll with color-wash spray.

Squeezing out the excess dye.

Stamping the doll with voodoo images.

Sewing a heart onto the doll's chest.

Altered Box & Contents Materials List:

- Adirondack Acrylic Paint
- Dabbers: espresso, mushroom, and snowcap
- Adirondack Alcohol Ink: espresso and butterscotch (Ranger)
- Beads, bits, and baubles
- Chipboard letters
- Cigar box
- Computer and printer
- Craft glue
- Cut-n-Dry Foam
- Distress Ink: Antique Linen and Vintage Photo
- Feathers
- Heavy cardstock: white, 8½ x 11
- Light chipboard: 8½ x 11
- Matte medium
- Miscellaneous "powders" for jars (sand, talcum, embossing, etc.)
- Miscellaneous voodoo trinkets for box (shells, fake hair, beads)
- Muslin scraps, unbleached
- Non-Stick Craft Sheet or scrap paper
- Old book pages
- Pins/pincushion
- Plastic baggie
- Rubber bands
- Sandpaper
- Scissors
- Small glass jars
- Waxed linen thread

Stamp a heart image on a dyed piece of scrap muslin and cut it out, leaving a ⅛-inch border. Also cut an appropriate length of white sewing thread with which to sew the heart onto the doll. Color the thread with the Color Wash Sprays so you have coordinating thread with which to sew the heart onto the doll's chest.

Cut an 8 x ¼-inch strip off the dyed piece of scrap muslin. Fray the edges and wrap the strip around the knee of the doll several times and tie a knot. Stamp the word *knee* over the wrap. You can also do this for any body part of the doll you would like.

CREATING THE ALTERED BOX

Find a cigar box that fits your doll and components. Then, working over a Non-Stick Craft Sheet or scrap paper, paint the entire outside of the box with an Adirondack Acrylic Paint Dabber in espresso color. Also paint inside the cigar box lid. My particular box had decorative paper around the edges that said, "Hand-Made," so I kept it as part of the design instead of painting over it.

Mark off the areas inside the box that will be sectioned off to house your jars. Measure the depth of your box and cut two strips of light chipboard to create the walls of your sections. Fold pieces into an L shape, determine proper fit, then trim. Attach the sections to the cigar box securely with tape on all sides. Then cut old book pages into random pieces and adhere them onto the inside bottom of your cigar box with matte medium.

You can use a computer for this step if you have one. Photograph your doll and upload the image into your photo program. I used Photoshop to manipulate the picture. Change image to grayscale. Increase contrast by darkening blacks and lightening whites. If you are working in Photoshop, go to Filter > Sketch >

Photocopy effects. This will create a photocopied look to your doll. (If you do not have photo-manipulation software, you can photocopy your doll on a copy machine using very high contrast.)

Create a label for the front of your voodoo box. Use a word-processing program and import the image of your doll. Write phrases to indicate what your particular doll can do ("Get Back at Enemies," "Influence People," etc.). Also list the contents of your box (Voodoo Doll, Itching Powder, Feathers, etc.). Print it out on white cardstock. You may want to print out various sizes to see which works best with your letters.

Painting the outside of the cigar box.

Cut out your label leaving a ⅛-inch border. Ink a 1-inch-square piece of foam with Distress Ink in antique linen. Use the foam to color the entire label. Then take another piece of foam and ink it with vintage photo Distress Ink. Use this to edge the perimeter of the label, creating an aged look, and set it aside.

Marking off the areas that will contain the jars.

Gather chipboard letters to spell out "Voodoo Doll." Give them two coats of Adirondack Acrylic Paint in snow cap color and two coats in mushroom color, letting them dry completely between each coat. When they're completely dry, lightly sand the edges of each letter for a worn look.

Taping the matboard walls in place.

Position all the elements on the front of the box and adhere them with matte medium. When the glue has dried, lightly rub around the letters with sandpaper. Use a pin to scratch additional highlights and to scratch tight areas between letters.

Using a pencil eraser dipped in white acrylic paint, create patterned rows of dots along the sides of your cigar box. With a piece of light chipboard trimmed shorter than the width of the box, dip into the paint and impress lines between the rows of dots. This will create a primitive look in your voodoo box. Using

Gluing book pages over the walls.

Using Photoshop to manipulate a photo of the doll.

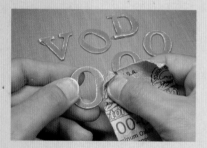
Using Distress Ink to age the perimeter of the box label.

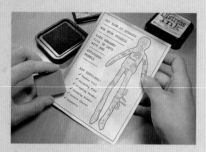
Sanding the edges of the chipboard letters to age them.

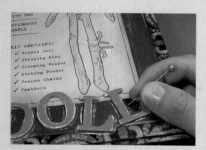
Using a pin to continue the aging process.

a foam square and vintage photo Distress Ink, color over the white paint to give it an aged look

Fashion a knob for the front of the box (you could use a drawer knob for this). I used two bingo chips and an old Portuguese coin. Glue the elements together with craft glue and then attach to the box.

Next you'll create a way to hang magic charms from your knob. Cut six 10-inch pieces of waxed linen thread. Tie them all together with several knots, 4 inches from the top. Gather together your miscellaneous voodoo-type trinkets. Tie them to the bottom thread sections. I used shells, beads, feathers, and fake hair. Make your piece only as long as the distance from the knob to the bottom of the box. Attach it to the knob by tying several knots. Add a drop of craft glue to secure it.

ASSEMBLING THE BOX CONTENTS

Gather your miscellaneous beads, bits, and baubles. Place them in a plastic baggie and squeeze a couple drops of Adirondack Alcohol Ink in espresso and butterscotch into the bag to age them. Seal it and shake the contents until they're coated. Pour out the pieces onto your Non-Stick Craft Sheet or scrap paper and let dry.

Next, you'll need the rest of the contents of your jars. You can use pins, powders, sand, or whatever else you like. Fill your jars to the rim and place a piece of packing tape on top. Trim the tape to $1/4$ inch over the edge of the lip. Place a scrap of undyed muslin over the lid, then use a rubber band to secure it. Trim the muslin to $1/4$ inch outside the rubber band and fray the edges by pulling off loose threads.

Using a piece of foam inked with antique linen Distress Ink, color over the muslin and the rubber band. Mist with water and then work the ink into the fabric with the foam. Repeat for all the jars and for the pin cushion.

Using your computer, create labels for your jars. Use different type styles to add interest, if you like. Print them out onto high-quality bond paper. Trim them to 1/16 inch from the paper's border. Color each label with a foam square holding antique linen Distress Ink. Go back around the edges using foam inked with vintage photo Distress Ink. Adhere the labels to the bottles and place all the elements in the altered cigar box to finish the voodoo kit.

Stamp credits: Just For Fun, Leavenworth Jackson, Making Memories, My Sentiments Exactly, River City Rubber Works, Stampers Anonymous

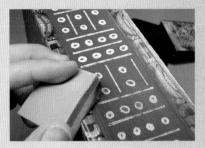

Aging the white paint with Distress Ink.

Attaching voodoo trinkets to the box knob.

Using Distress Ink to age computer-generated labels.

Adhering the labels to the voodoo bottles.

The interior of the box showing the voodoo doll and the magic potions.
Photograph by Debra Tlach.

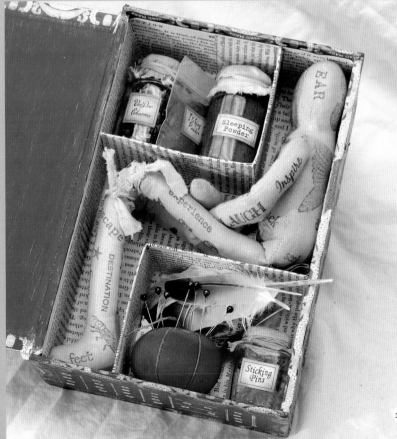

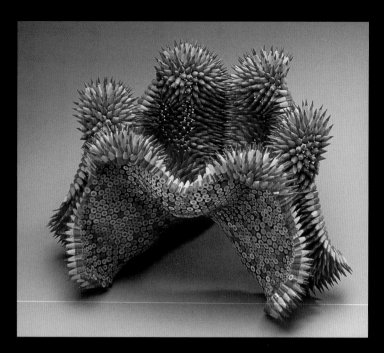

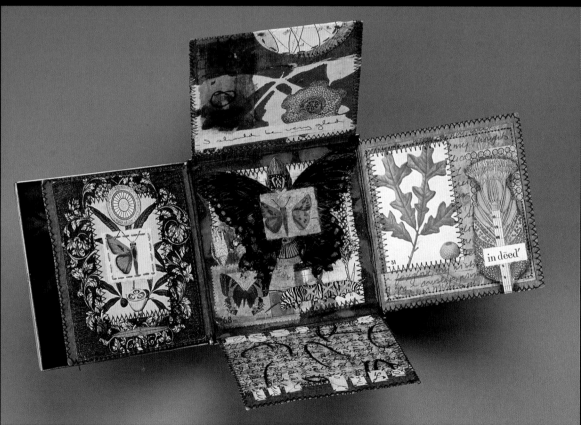

Never Really Began, Indeed by Sharon McCartney. A vintage compact forms the base of this collaged and stitched mixed-media work with flap-page foldouts. Photograph by John Polak.

Top: *Seethe*, altered art created with hundreds of pencil stubs joined with peyote stitching, by Jennifer Maestre. Photograph by Dean Powell.

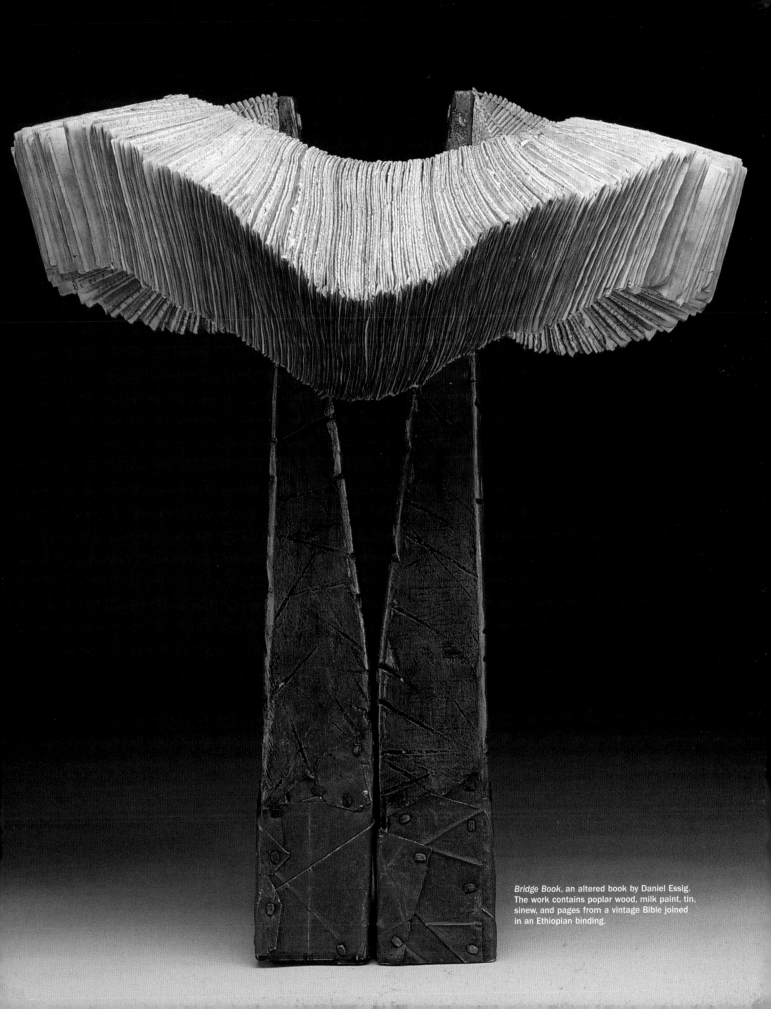

Bridge Book, an altered book by Daniel Essig. The work contains poplar wood, milk paint, tin, sinew, and pages from a vintage Bible joined in an Ethiopian binding.

CONTRIBUTORS

Lisa Austin
Louisville, KY
www.Laustinmixedmedia.com
lpaustin@bellsouth.net

Mary Bennett
Santa Fe, NM
Squiben@aol.com

Michelle Bernard-Harmazinski
Ocean Grove, NJ
michelle@YesterdaysTrashArt.com
www.YesterdaysTrashArt.com

Thomas M. Cassidy
Minneapolis, MN
Tom.cassidy@mmha.com

Gabe Cyr
Aberdeen, WA 98520
www.gabecyr.com
gabecyr@yahoo.com

Michael deMeng
Missoula, MT
www.michaeldemeng.com
assemblage@michaeldemeng.com

James Erikson
Philadelphia, PA
www.jameserikson.com
j.erikson1@verizon.net

Daniel Essig
Asheville, NC
www.danielessig.com
dessignc@earthlink.net

Victoria Hall
Norwich, England
Victoria@hall1120.fsbusiness.co.uk

Janet Hofacker
Meridian, ID

Mary Howe
Stonington, ME
mchbook2@verizon.net

Martina Johnson-Allen
Laverock, PA
Efuntina@aol.com

Greg Jordan
www.JordanFineartjewelry.com
jorartjlry@verizon.net

Joanne B. Kaar
Caithness, Scotland
www.joannebkaar.com
info@joannebkaar.com

Susan Lenart Kazmer
Vermilion, OH
www.susanlenartkazmer.net

Ruth Kempner
State College, PA
Ruthkpws@pennswoods.net

Anne Kenyon
State College, PA
annekenyon4@comcast.com

Lin Lacy
St. Paul, MN
ljl@hotmail.com

Elaine Langerman
Washington, DC
www.elainelangerman.com
elangerman@comcast.net

Nancy Goodman Lawrence
Los Angeles, CA
www.nancygoodmanlawrence.com
tearmyartout@mac.com

Claudia Lee
Liberty, TN
paperlee@dtccom.net

Julie Leonard
Iowa City, IA
Julia-leonard@uiowa.edu

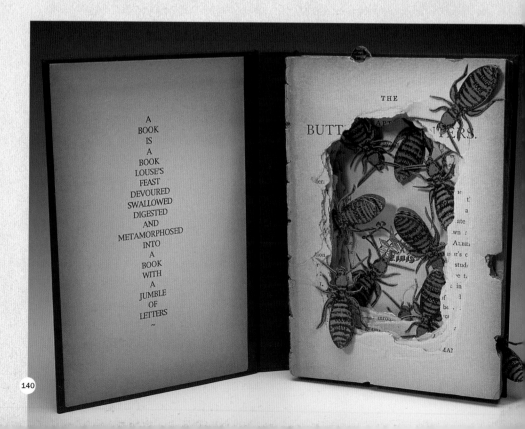

A Book Louse's Feast by Mary Howe.
(See also page 120.)

Peter Madden
Boston, MA
www.petermadden.com
peter@petermadden.com

Jennifer Maestre
Concord, MA
www.jennifermaestre.com

Jeffery Mathison
Spring Mills, PA
www.artbymathison.com
jcmaps@mac.com

Paul Maurer
Serafina, NM

Sharon McCartney
Belchertown, MA
lilypeek@aol.com

Betsy Miraglia
Bryn Mawr, PA
Paperfly1@aol.com

Leo F. Monahan
Barnardsville, NC
www.leomonahan.com
leomonahan@charter.net

Jennifer Lee Morrow
Deer Isle, ME
www.jenniferleemorrow.com
jen@jenniferleemorrow.com

Linda O'Brien
N. Perry Village, OH
www.burntofferings.com
gourdart@burntofferings.com

Opie O'Brien
N. Perry Village, OH
www.burntofferings.com
gourdart@burntofferings.com

Touchstones by Pamela Paulsrud.
(See also page 122.)

Tara O'Brien
Philadelphia, PA
inkfishpress@mail.com

Carol Owen
Pittsboro, NC
www.carolowenart.com
gowen1@nc.rr.com

Pamela Paulsrud
Wilmette, IL
www.pamelapaulsrud.com
paulsrud@prodigy.net

Jennifer Philippoff
State College, PA
joynglee@yahoo.com

Jill Quillian
Fond du Lac, WI
www.jillsquills.com
jill@jillsquills.com

Alyce Ritti
Port Matilda, PA
www.artalliancepa.org/AlyceRitti.htm
alyceritti@artalliancepa.org

Richard Salley
Moreno Valley, CA
www.rsalley.com
art@rsalley.com

George Sargent
Woonsocket, RI
www.dragonflybinderystudio.com
geosargent@verizon.net

Patricia Sargent
Woonsocket, RI
www.dragonflybinderystudio.com
geosargent@verizon.net

Ukulele Series Book # 18, Hawaii: Isle of Dreams by Peter and Donna Thomas. To create this work, Peter and Donna sawed a ukulele in thirds to transform it into a bent wood shaker box. A book was then cut to the shape of the box and placed inside it.

Susan Joy Share
Anchorage, AK
sjshare@alaska.net

Carole Shearer
Sonoma, CA
jc.shearerart@yahoo.com

Larry Thomas
Athens, GA

Peter and Donna Thomas
Santa Cruz, CA
www.members.cruzio.com/
~peteranddonna/
peteranddonna@cruzio.com

Marjorie Tomchuk
New Canaan, CT
www.Mtomchuk.com
Mtomchuk@aol.com

Nelle Tresselt
Danbury, CT
ntresselt@snet.net

Robert Villamagna
Wheeling, WV
www.robertvillamagna.com
constructart@comcast.net

FURTHER READING

Cyr, Gabe. *New Directions in Altered Books*. New York: Lark Books, 2006.

Haun, Gregory Cosmo. *Photoshop Collage Techniques*. Indianapolis, IN: Hayden Books, 1997.

Maurer-Mathison, Diane. *The Art of Making Paste Papers*. New York: Watson-Guptill Publications, 2002.

Maurer-Mathison, Diane. *Paper in Three Dimensions*. New York: Watson-Guptill Publications, 2006.

Maurer-Mathison, Diane. *The Ultimate Marbling Handbook*. New York: Watson-Guptill Publications, 1999.

O'Brien, Linda and Opie. *Metal Craft Discovery Workshop*. Cincinnati: North Light Books, 2005.

Owen, Carol. *Crafting Personal Shrines*. New York: Lark Books, 2004.

DIANE MAURER-MATHISON is an internationally recognized paper artist, teacher, and award-winning author. Her work is in the collections of many museums and libraries throughout the world. Numerous design commissions include work for Lenox China and Godiva Chocolates. She has made guest appearances on *The Carol Duvall Show*, *Home Matters*, and *Martha Stewart Living*. She lives in Spring Mills, Pennsylvania, with her husband Jeffery and dog Molly.

INDEX

Acid-free paper, 25
Adhesive film, 106
Adhesives, 16, 84
Adirondack Acrylic Paint Dabber, 134
Adirondack Alcohol Ink, 136
Adirondack Color Wash dyes, 17, 42
Adobe PhotoShop, See PhotoShop (Adobe)
Aging collage papers, 25–27
Altered art, 9, 104–138
 defined, 11, 104
Altered books, 106–122
 children's board books, 115–116
 envelope pockets, 111
 folding book pages, 111
 getting started, 107
 horizontal or vertical slits, 111
 nontraditional, 118–122
 pop-ups, creating, 112–114
 shadowboxes, creating, 114–115
 traditional, 107, 107–115
 windowed pop-up, 113
 windows and doors, creating, 108–109
Altered clothing/objects, 122–138
 books, 106–122
 collage papers, 24
 cigar box and muslin doll, 132–137
 coat, 124
 compacts, 126
 dress form, 131
 needlework and vintage textiles, 127
 pencils and nails, 128
 pocketbook, 124
 ukuleles, 126–127
Analogous color scheme, 29
Antiquing tea wash, 26
Archival PVA, 16
Arp, Jean, 14
Art Deckle Ruler (Design a Card), 19
Assemblage, 9
Assemblage art, 77–103
 artists discussing their work, 78–81
 current embrace of, 11
 found materials, altering, 82–83
 natural found objects, 82
 tools/techniques for creating, 83–84
Assemblage art dolls, 86–88
Assemblage artists, role of, 11
Assemblage jewelry, 88–92
Assemblage materials, finding, 81–84
Assemblage shrines, 93–94
Attached papers, sanding, 27
Austin, Lisa, 124–125

Barton, Carol, 124
Beading, embellishment with, 61
Bennett, Mary, 118–119
Bentwood shaker box, 126, 142
Bernard-Harmazinski, Michelle, 17, 132–137
Binder's board, 19
Boku Undo colors, 42
Bone folder, 17
Brads, 19
Braque, Georges, 13
Brayer, 39
 used to roll over an inked leaf, 49
Brulage, 14, 28
Brushes, 17
 and paste papers, 37
 and suminagashi marbling, 33
Bubble wrap prints, 47

Calligraphy pens, and collage, 36
Caran D'Ache water soluble crayons, 17
Cassidy, Thomas M., 114
Cello-Mount, 16
Chartpak Dry Bond Adhesive, 16
Children's board books, altering, 115–116
Circle cutters, 18
Coasters, as decorative paper, 20
Collage:
 adding elements, 14
 adhesives, 16
 bone folder, 17
 brushes, 17
 choice of materials, 14
 color/coloring agents, 17
 compared to drawing/painting, 9
 and cubist art, 13
 defined, 13
 materials/equipment, 16–19
 medium, 14
 skills required for, 14
 three-dimensional, 9
Collage materials, creating, 31–35
Collage papers, 20–22
 aging, 25–27
 attaching, 16
 creating your own, 23–24
 distressing, 25, 27–28
 domestic found papers, 21
 foreign found papers, 21–22
 purchased papers, 22–23
 texturing/altering, 24
Collagraph printing, 44–45
Color application, and leaf prints, 49

Color palettes/color schemes, 29–30
Color Wash Spray, 132, 134
Color wheel, 29
Colors, 17, 29
 and suminagashi marbling, 33
 temperature of, 29
Combed papers, 39
Complementary color composition, 29
Computers, using in collage, 62–63
Cooled transfers, 51
Copyright issues, 70
Corel Painter, 70
Cornell, Joseph, 77–78
Cornstarch recipe, paste papers, 38
Cubists, 13
Cutting mat, 17
Cutting tools, 18
Cyr, Gabe, 87

Dadaists, 77–78
Décollage, 14
Decorative papers:
 creating your own, 14, 23–24
 purchasing, 22
Découpage, 14
deMeng, Michael, 80, 82, 84, 93, 123, 124–125
Design a Card, 19
Digital cameras, 18–19
Digital collage, 65
Digital montage, 65
Dimension, adding to collage papers, 24
Distress Ink, 134, 136
Distressing collage papers, 25, 27–28
Dr. Ph. Martin's metal paints, 83
Dry adhesive, 107
Dry adhesive tapes, 16
Dry brushing, 27, 82–83
DuChamp, Marcel, 77

E6000 (adhesive), 17, 84, 116
Embossing, 43
Embroidery, embellishment with, 61
Envelope pockets, 111
Erikson, James, 53
Essig, Daniel; 120, 138
Everse, Lea, 26
Exotic papers, 22

Fabric prints, 47
First collage, creating, 53–56
Flour paste recipe, 37
Foam board, 19
Foamcore, 18
Found-object art, See Assemblage art
Found papers, 21
Frottage, 14
Fumage, 14, 28

Glassine envelopes, 111
Glue stick, 106
Grattage, 27–28

Hair picks, and collage, 36
Hall, Victoria, 55
Haun, Gregory Cosmo, 65
Heat transfer, 51
Hofacker, Janet, 17, 25, 26–27, 78–79, 82–83, 84, 103, 115–117, 130–131
Howe, Mary, 120

Illustration board, 19
Inkjet printer transfer, 51
Inks, and leaf prints, 49
Iridescent inks, 17

Johnson-Allen, Martina, 30, 101
Jordan, Greg, 83, 102
Jordan, BJ, 83

Kaar, Joanne B., 27–28
Kazmer, Susan Lenart, 89
Kempner, Ruth, 14–15, 16, 28, 44–45, 49, 50, 72
Kenyon, Anne, 4–5
Kitchen tools, and collage, 36
Kosher salt, and salt prints, 47

Lace prints, 47
Lacy, Lin, 50–51
Langerman, Elaine, 16, 63, 65
Lawrence, Nancy Goodman, 20, 56–57
Layering, 61
Leaf prints, 48–50
 inking the leaf, 49
 making the print, 49–50
 materials/equipment, 49
Lee, Claudia, 23, 60
Leonard, Julie, 12, 120
Liquid Nails, 84

Madden, Peter, 81–82
Maestre, Jennifer, 128–130, 138
Map collages, 56–57
Mat cutter, 18
Mat knife, 17, 18, 115
Matboard, 18–19

Mathison, Jeffery, 65–71, 83, 95–100
Matte medium, coating papers with, 22
Maurer-Mathison, Diane, 10, 12–13, 31, 36, 40, 73
Maurer, Paul, 18–19, 141
McCartney, Sharon, 10–11, 36, 61, 61–62, 104, 106, 126, 127, 138
Metal hole punches, 18
Metal square, 18
Miraglia, Betsey R., 44
Misting bottle, 18
Mixed-media assemblage dolls, 86–88
Mixed-media fiber collage, 61–62
Mixed-media paper collage, 58–59
Monahan, Leo F., 29, 59, 102
Monochromatic color scheme, 29
Morrow, Jennifer Lee, 74, 102
Mushroom printing, 50

Natural found objects, and assemblage art, 82
Needlework, altered, 127
Neutral pH paper, 22
Newsprint, 22
Non-acidic paper, 22, 25
Non-Stick Craft Sheet, 134, 136
Nontraditional altered books, 118–122
 nontraditional niches, 120
 paper folding/manipulation, 118–119
 tearing/cutting pages and covers to create sculptural form, 121–122

O'Brien, Linda, 79, 87–88
O'Brien, Opie, 78, 79, 86
O'Brien, Tara, 120
Orizomegami paper, 40–42
 dyeing the paper, 42
 flattening the papers, 42
 folding the paper, 41
 over-dyeing, 42
 pre-wetting the paper, 42
Owen, Carol, 107, 108, 109

Packing tape transfer, 51
Paint Shop Pro, 70
Paints, and paste papers, 37
Palimpsest, 104
Paper elements, tacking in place, 18
Paper slide mounts, as decorative paper, 20
Paper tearing, and ruler, 19
Papercasting, 43
Paste, 37
Paste containers, 37
Paste papers:
 applying the paste, 38
 coloring the paste, 38
 cornstarch recipe, 38
 drying, 39
 equipment, 37
 flour paste recipe, 37
 making, 36–39
 multiple-image prints, 39
 patterning ideas, 38–39
 preparing the paper, 38
 technique, 36
 work surface, 37
Patina kits, 83
Patterning tools, and paste papers, 37
Paulsrud, Pamela, 122
Pearlescent inks, 17
Philippoff, Jennifer, 32
Phillips, Tom, 107
Photo transfer techniques, 50–51
 heat transfer, 51
 inkjet printer transfer, 51
 packing tape transfer, 51
Photocopies, 22
Photomontage, 14
Photoshop (Adobe), 63, 66–67, 134–135
 Background Eraser tool, 68
 Background Layer, 70
 Brush tool, 68
 Clone tool, 69
 Gradient tool, 70
 Lasso tool, 67, 68, 70
 Layers palette, 68
 Magic Wand tool, 69–70
 Mask tool, 67
 Transform tool, 69
Picasso, Pablo, 13, 14
Plant press, and leaf prints, 49
Plastic triangle, 18–19
Plastic wrap prints, 46–47
Play bills, as decorative paper, 20
Plexiglas, 37, 49
Pocket books, 124
Polyvinyl acetate glues (PVA), 16
Positioning papers, 53–54
Pretzel salt, and salt prints, 47
Primary colors, 29
Printmaking:
 bubble wrap prints, 47
 collagraph printing, 44–45
 cutting out the design, 45–46
 fabric prints, 47
 plastic wrap prints, 46–47

rubber stamping, 44–45
salt prints, 47
Printmaking techniques, 43–44
Prints, as decorative paper, 20
.psd format, 70–71
Purchased papers, 22–23
Pyrography machine, 28

Quillian, Jill, 24

Raised stamp pad ink, 27
Receipts, as decorative paper, 20
Ritti, Alyce, 21, 52, 58–59
Rubber graining combs, and collage, 36
Rubber stamping, 44–45
Rulers, 18–19
Rust kits, 83

Safety-Kut, 44
Salley, Richard, 64–65, 90, 91–92
Salt prints, 47
Sanding attached paper, 27
Sargent, George, 74–75
Sargent, Patricia, 62–63
Schwitters, Kurt, 77
Scrap paper, 134, 136
 and leaf prints, 49
Secondary colors, 29
Shadowboxes, creating, 114–115
Share, Susan Joy, 86
Shearer, Carole, 48
Skimming, 33
Smaller metal rulers and squares, and collage edge, 18
Soldering irons, 84
Sponges, and paste papers, 37
Squares, 18–19
Stamp pads, 44
Steel square, 18
Stitched paper collage, 60–61
Suminagashi marbling, 32–33
 adjusting your colors, 33–34
 applying/patterning colors, 34–35
 flattening the marbled papers, 35–36
 making the print, 35
 materials/equipment, 33
 skimming, 33
Suminagashi paper, 31–32
Swivel knife, 18

Table salt, and salt prints, 47
Tacks, 19
Tearing papers, 19
Teaspoons, and paste papers, 37
Teflon folder, 17
Tertiary colors, 29
Textiles, altered, 127
Texturing collage papers, 24
Thomas, Larry, 124, 125
Thomas, Peter and Donna, 127
Three-dimensional collage, See Assemblage Art
Tom Bow, 16
Tomchuk, Marjorie, 43–44
Traditional altered books, 107–115
 altering covers and pages, 108
 book cover decorations, 108–109
 masked text, 108
 techniques, 108
Translucent ink wash, 26
Tresselt, Nelle, 55
Triadic color compositions, 28
Tub, and paste papers, 37
Tweezers, and leaf prints, 49

V-blades, 44
Villamagna, Robert, 9, 76–77, 80, 82, 84, 85
Vintage textiles, altered, 127
Voodoo Doll Kit, 132–137
 assembling the box contents, 136–137
 creating the altered box, 134–136
 creating the voodoo doll, 133–134
 doll materials list, 133

Wallpaper, as decorative paper, 20
Walnut ink, 26
Warping, 19
Water, and suminagashi marbling, 33
Water buckets, and paste papers, 37
Watercolor block, 46
Watercolor brushes, 17
Watercolor paper, 19, 46
Wax resist/batik process, 60–61
Welding equipment, 84
Wood backing, 19
Woodburning tool, 28
Work surface, for paste papers, 37

X-Acto knife, 17, 18, 44, 107, 115
Xyron machine, 17

Yard-long metal straightedge, 18
Yes! Glue, 116
Yes! Paste, 16